2022

COLLECTED LETTERS

2022

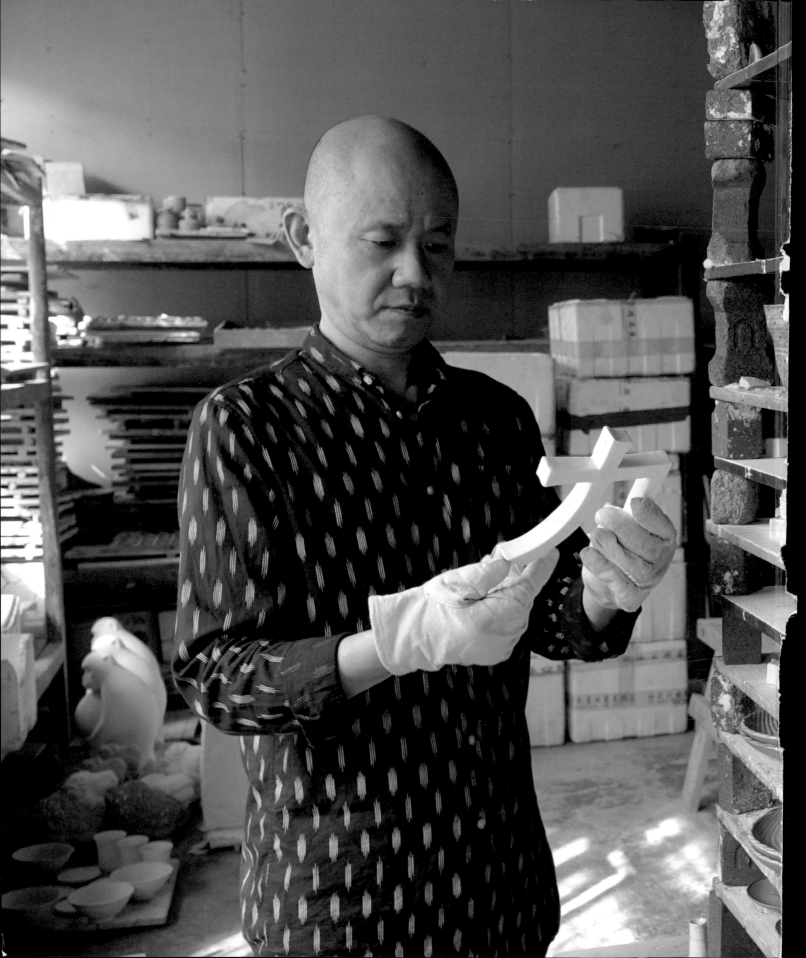

COLLECTED LETTERS AN INSTALLATION BY LIU JIANHUA

Edited by

Pedro Moura Carvalho

Forewords by

Jay Xu

Linda Shen I ei

Texts by

Liu Jianhua

Tiffany Wai-Ying Beres

Karin G. Oen

Asian Art Museum

San Francisco

∀ Asian

Published by
Asian Art Museum
Chong-Moon Lee Center for Asian Art and Culture
200 Larkin Street
San Francisco, CA 94102
www.asianart.org

Library of Congress Cataloging-in-Publication Data
Names: Asian Art Museum of San Francisco, author. | Liu, Jianhua, 1962– | Beres, Tiffany Wai-Ying, 1983– | Oen, Karin G., 1978– | Carvalho, Pedro Moura, editor.
Title: Collected letters : an installation by Liu Jianhua / edited by Pedro Moura Carvalho ; forewords by Jay Xu and Linda Shen Lei ; texts by Liu Jianhua, Tiffany Wai-Ying Beres, and Karin G. Oen.
Description: San Francisco, CA : Asian Art Museum, 2016. | Includes bibliographical references.
Identifiers: LCCN 2016004844 | ISBN 9780939117758 (paperback)
Subjects: LCSH: Liu, Jianhua, 1962- Collected letters—Exhibitions. | Site-specific installations (Art)—California—San Francisco—Exhibitions. | Ceramic sculpture, Chinese—California—San Francisco—Exhibitions. | Alphabet in art—Exhibitions. | Chinese characters in art—Exhibitions. | Asian Art Museum of San Francisco—Exhibitions. | BISAC: ART / Collections, Catalogs, Exhibitions / General. | ART / Asian.
Classification: LCC N7349.L5365 A63 2016 | DDC 730.92—dc23
LC record available at http://lccn.loc.gov/2016004844

Collected Letters is organized by the Asian Art Museum of San Francisco. This acquisition was made possible by the Society for Asian Art in honor of the Asian Art Museum's 50th Anniversary.

The Asian Art Museum–Chong-Moon Lee Center for Asian Art and Culture is a public institution whose mission is to lead a diverse global audience in discovering the unique material, aesthetic, and intellectual achievements of Asian art and culture.

Produced by the Publications Department, Asian Art Museum
Clare Jacobson, Head of Publications

Designed by Bob Aufuldish, Aufuldish & Warinner

Distributed by:
North America, Latin America, and Europe
Tuttle Publishing
364 Innovation Drive
North Clarendon, VT 05759-9436 U.S.A.
Tel: 1 (802) 773-8930; Fax: 1 (802) 773-6993
info@tuttlepublishing.com
www.tuttlepublishing.com

Asia Pacific
Berkeley Books Pte. Ltd.
61 Tai Seng Avenue #02-12
Singapore 534167
Tel: (65) 6280-1330; Fax: (65) 6280-6290
inquiries@periplus.com.sg www.periplus.com

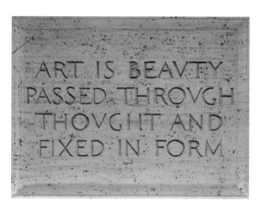

—FRANÇOIS DELSARTE

Inscription in the Loggia of the Asian Art Museum

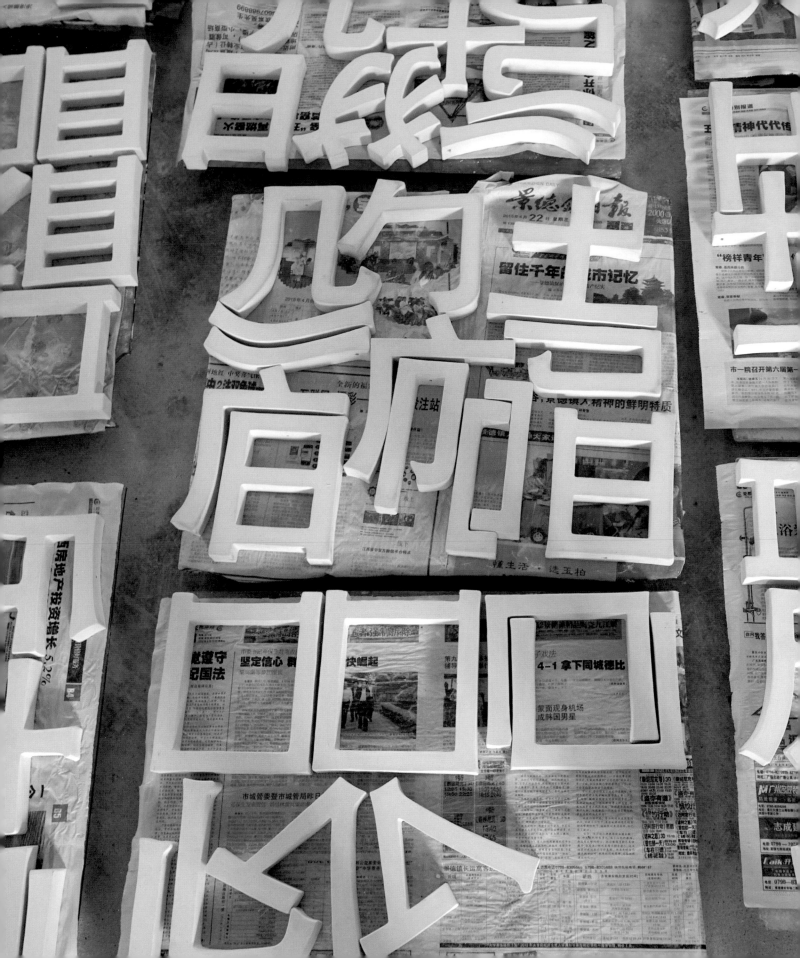

CONTENTS

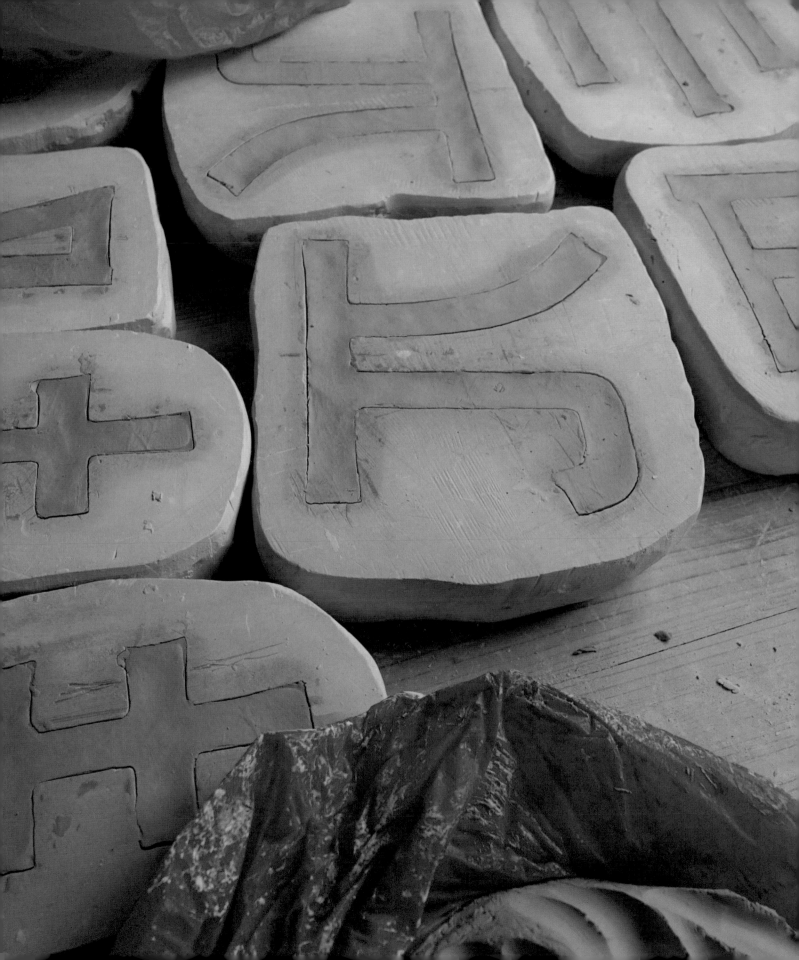

FOREWORD

JAY XU

China has long been associated with porcelain; in fact, "china" has come to refer to porcelain in common usage. The Asian Art Museum of San Francisco is also identified with the material, as it houses one of the major collections of Chinese ceramics in the United States. This exceptional collection, much of which is exhibited in the museum's second-floor Loggia, tells the long history of porcelain's diversity and richness.

Liu Jianhua's *Collected Letters* brings this story into the contemporary era. The installation respects the inherent versatility and vitality of porcelain making in China. It uses the most fundamental ingredient of culture—the elements of written words—as its content. In this artwork, porcelain forms of the Latin alphabet and Chinese radicals suggest a connection between cultures. Through it, the museum is exhibited as the embodiment of knowledge. Its Loggia, where words of wisdom from the past are carved onto its lintels, reminds us of the continuation of knowledge from the museum's former incarnation as a library. The nearly hundred-year-old Loggia is reimagined through *Collected Letters*, which asks viewers to look again at the building blocks of words and, therefore, cultures.

I want to thank all the people who made *Collected Letters* possible. First and foremost, thanks to the Society for Asian Art, which, under the leadership of Linda Shen Lei, commissioned the installation as a fiftieth-anniversary gift to the Asian Art Museum.

This work is a celebration of the SAA's long commitment to the museum. Thanks to Pedro Moura Carvalho, former Deputy Director, Arts & Programs, who initiated and coordinated the project, and to Karin G. Oen, Assistant Curator of Contemporary Art, who curated it for the museum. My gratitude extends to Tiffany Wai-Ying Beres, who facilitated contact with the artist and contributed to this catalogue. Thanks to the staffs at Pace Beijing and Pace New York for their assistance in coordinating this acquisition and installation. Lastly, I offer my indebtedness to Liu Jianhua for creating a momentous installation that will awaken and inspire visitors for years to come.

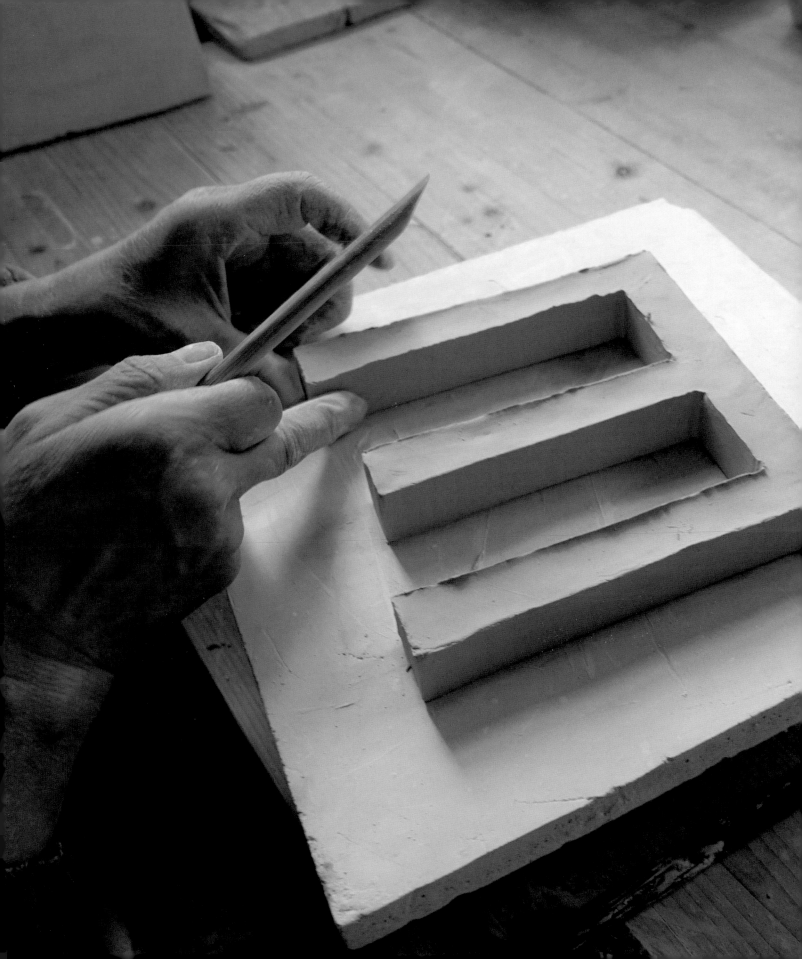

FOREWORD

LINDA SHEN LEI

President, Society for Asian Art

The Society for Asian Art (SAA), established in 1958 by a group of Asian art enthusiasts, played an instrumental role in the founding of the Asian Art Museum. As the museum grew from Avery Brundage's founding collection into a thriving cultural institution at the San Francisco Civic Center, SAA has continued to serve as a close ally and support organization; in addition to funding critical museum initiatives, SAA provides more than a hundred education programs each year.

To commemorate the public opening of the Asian Art Museum fifty years ago, SAA members have generously under-written *Collected Letters*, an important new art installation by the Shanghai-based artist Liu Jianhua. This golden anniversary gift affirms the two organizations' special relationship as well as our shared commitment to promoting the appreciation of Asian art and culture.

Collected Letters began in 2014 when SAA was approached by the Asian Art Museum's then Deputy Director Pedro Moura Carvalho with the idea for an art commission. From that first meeting, we were intrigued by Liu Jianhua's well-known instal-lations in Chinese porcelain and the possibility of introducing contemporary art to the museum's Loggia, a gallery dedicated to traditional Asian ceramics. Thanks to Moura Carvalho's intro-duction, the artist met with the SAA board. Liu's proposed design featured tools and components of written words, which

aligned perfectly with SAA's mission to support education and engage the public in an open-ended dialogue with Asian art. The SAA board voted unanimously to proceed with *Collected Letters*, knowing that it will teach and inspire museum visitors for many years to come.

The Society for Asian Art acknowledges Pedro Moura Carvalho for the inception of *Collected Letters*; Karin Oen for coordinating the project to its completion; Kim Bush Tomio and her staff for overseeing all city and museum logistics; the museum's talented conservation, design, and preparation staff for its ingenious installation; Clare Jacobson for producing this book; Director Jay Xu for his wholehearted support; and, most important, the artist Liu Jianhua.

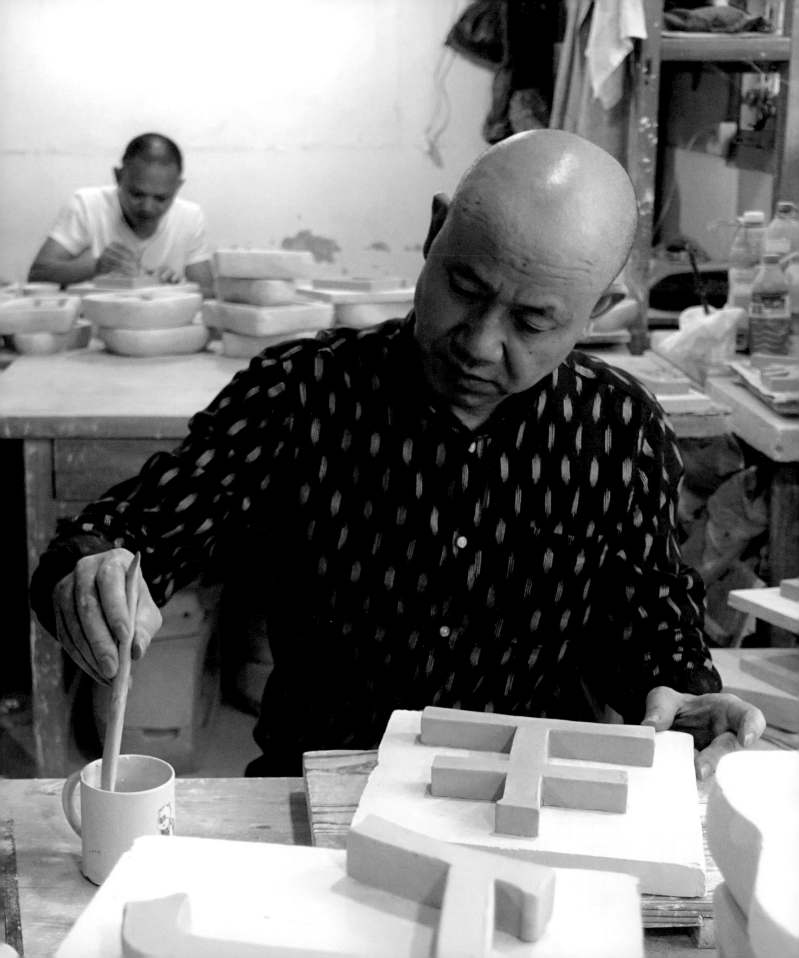

ARTIST'S STATEMENT

LIU JIANHUA

Collected Letters began in May 2014 with an invitation from the Asian Art Museum of San Francisco and the Society for Asian Art. For this, I made a special trip to San Francisco in mid-November 2014 to discuss the project and review its location. The museum building, formerly San Francisco's Main Public Library, has a strong cultural and historical context. The role and function of its conversion from library to museum were to extend its cultural life.

Collected Letters uses traditional Chinese porcelain as its medium; porcelain is one of the materials that I have used for many years to create works. When choosing this material for this installation, I wanted to bring it to the practice of contemporary art and to give it new functions. I did this by hanging porcelain forms.

I selected fifty-two Latin letters (lower- and uppercase) and forty Chinese radicals (components of Chinese characters) as the forms for the work. In the combination of these letters, different languages and words in both the East and the West are present; in this way the forms suggest different meanings. The artwork is in the museum's Loggia, where there are many philosophical quotes, and all these quotes can be formed by the letters in *Collected Letters*. The mixed text forms of the objects make people look for content in the installation and for the essential possibilities of things. In this era of high technology and rapid information exchange, letting ourselves slow down and think more is a hurdle for people, and it is a hurdle that we have to face.

Thanks very much to the Asian Art Museum and the Society for Asian Art for inviting me to do this meaningful and challenging project. For this installation, our studio proposed five different approaches, and the one that has been realized is the closest to the core mission of the Asian Art Museum. The artwork was produced in Shanghai, Jingdezhen, and San Francisco, and its completion achieves its intended expression. I expect any number of reactions from the visitors who see it. Thanks again to all those who were involved in and supported the work.

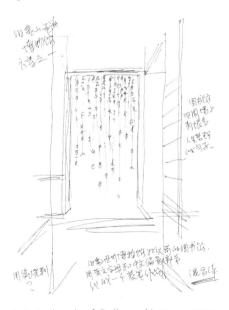

Artist's sketch of *Collected Letters*, 2015

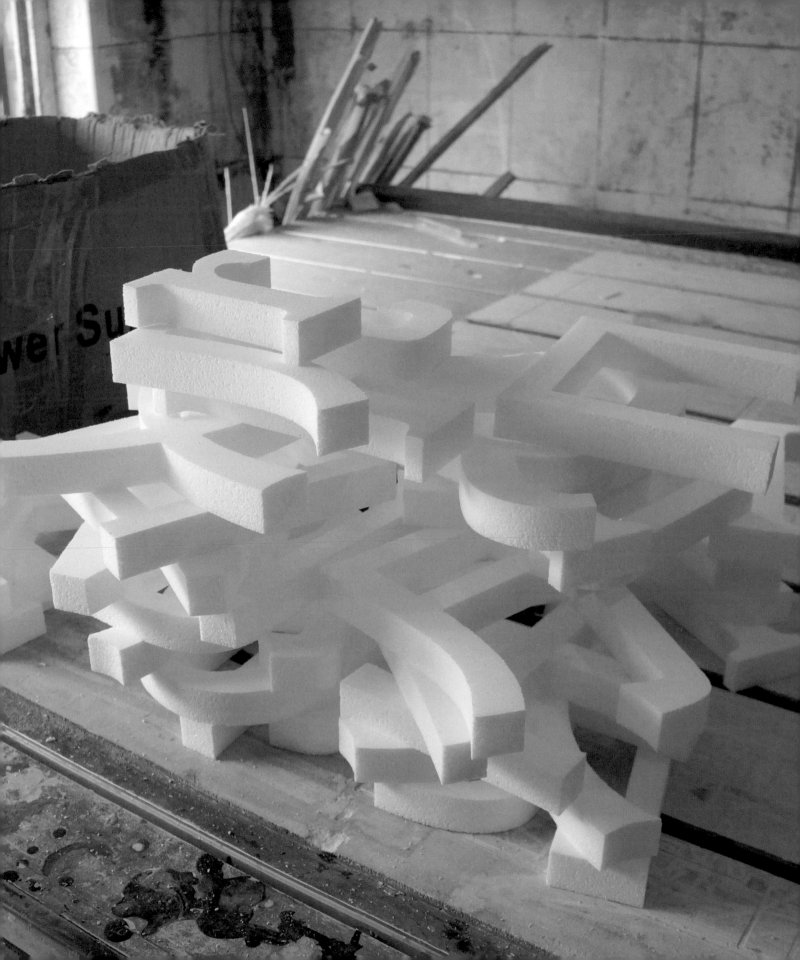

BUILDING BLOCKS: THE CONCEPT AND PRODUCTION OF *COLLECTED LETTERS*

TIFFANY WAI-YING BERES

Liu Jianhua's installation *Collected Letters* (混合体) is a one-of-a-kind artwork made for the Asian Art Museum of San Francisco. In 2014, shortly after Pedro Moura Carvalho was appointed Deputy Director for Art and Programs at the museum, he made it a priority to identify areas that were underused and could be developed in dynamic new directions. The second-floor Loggia in the Chinese ceramics gallery was identified as a clear candidate, because of its prime location and paucity of foot traffic. Moura Carvalho sought to find a contemporary artwork that would enliven the space and speak to the historical ceramic art on display, as well as contribute to the architecture and history of the building. Who better than Liu Jianhua to transform this section of the building in a profound new direction? One of China's best-known sculpture and installation artists, Liu has focused his long-standing engagement with the medium of ceramics on turning the material into something beyond the material, and into something that resonates with contemporary sociocultural issues.

At the end of 2014, upon the invitation of the Asian Art Museum, Liu Jianhua came to visit the museum in between exhibitions at the Queens Museum and the Vancouver Art Gallery. His three-day trip, his first to San Francisco, was an opportunity to get a feel for the City by the Bay. He said, "I was impressed by the richness and diversity of the population. It struck me as an extremely open and independent place—a multicultural city. The same is true of the Asian Art Museum, which was clearly a reflection of this diversity. This museum was very different from a typical art museum—the collections, the visitors, and the building itself all seemed to be a coming together of different nationalities, ethnicities, and cultures."[1] The museum building that Liu mentioned here has a rich and multifaceted history. Designed by George W. Kelham and built in 1917, this structure initially served as the city's Main Public Library at the San Francisco Civic Center. In 1989, the building was

damaged in the Loma Prieta earthquake, and the library relocated. The Asian Art Museum, which had outgrown its location in Golden Gate Park, moved into the building in 2003. The extensive renovations to the museum sought to enhance the structure without damaging its historic elements. Traces of the building's original function as a library are still found throughout, including the second-floor beaux arts Loggia, where inspiring quotations from famous authors are inscribed on the lintel. This confluence of histories, both Asian and San Franciscan, are the inspiration for *Collected Letters*.

Upon his return to his Shanghai studio, Liu Jianhua came up with five proposals for the Loggia space. Most of his preliminary designs were based on former works, such as *Screaming Walls*, featuring ceramic black ink drops seemingly dripping from the walls, and *Blank Paper*, giant sheets of white porcelain that invite audience interpretation. All these installations featured ceramics extending from the stone architecture. Ultimately, however, the project that was selected by the Asian Art Museum and the Society for Asian Art was an entirely new concept for Liu—a multidimensional, hanging ceramic installation. The most technically complex of all the proposals, this mobile sculpture would be composed of thousands of Latin letters and Chinese radicals (components of Chinese characters), each individually made from a pure white-glazed porcelain. Given the building's historical connection to the written word, the subject seemed particularly apropos.

On the most basic level, this work is composed of letters and radicals, the building blocks of words and the written language. We know the compact set of twenty-six letters of the English alphabet. Chinese radicals, however, are based on pictographs and are known as *pianpiang* (偏旁): the components of a character that indicate its meaning. For example, two radicals—水 (*shui*), a pictograph of streams flowing together or water and 冫(*bing*), a pictograph of ice crystals—come together to form 冰 (*bing*), ice. The 冫radical hints that the character pertains to ice, much like "glaci" (from the Latin *glacies*) in "glacier." Chinese characters have evolved over millennia, so it is not possible to credit any one individual for their invention. However, popular accounts recognize the legendary figure Cangjie from the third millennium BCE (an official in the court of the Yellow Emperor, Huangdi) as inventing writing after being inspired by the claw prints of birds. For this reason, Chinese radicals, like Chinese characters, sometimes suggest their meaning

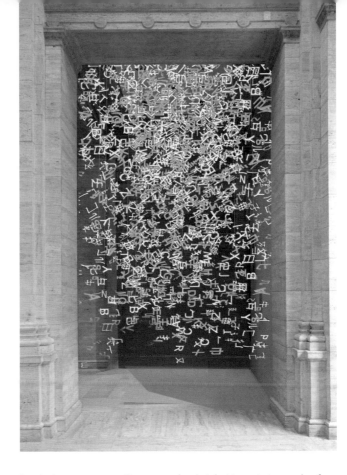

Artist's rendering of *Collected Letters*, 2015

by their appearance. For example, 屮 (*che*) is a pictograph of a sprouting plant, and when two 屮 are put together, the character becomes 艸 (*cao*), meaning "grass."

The Chinese have long considered the advent of writing as the beginning of civilization. In ancient China, oracle bones, the earliest known examples of ancient Chinese writing, were used for divination—written radicals were imbued with a spiritual quality and power. According to the archaeologist and sinologist K. C. Chang, "The written record held the secret of the governance of the world; the inscriptions were identified with the information they contained because when writing began they themselves were part of the instruments of the all-important heaven–earth communication."[2] In a similar way, art is a marker of civilization. Recently scientists have confirmed that the nearly forty thousand-year-old cave paintings of Sulawesi, Indonesia, are the first tangible traces of what we may call "art"—the basic impulse to understand our place in the world and to affirm our existence through the act of leaving visible marks. Artistic mediums have evolved in the following millennia from simple protograffiti and petroglyphs and totem poles to oil on canvas and ink paintings, to sculptures in bronze and marble, and, finally, to contemporary art in all its manifestations. But the role of the artist in his purest form—as a philosophical inquirer, a visionary of the

abstract questions of life and death, of cosmology and existence—has not changed. Art, like the written language, is a system of communication, a unifying representation of the ideas and beliefs of a culture. When Latin letters and Chinese radicals come together as art, they represent the apotheosis of these two great civilizations.

Collected Letters certainly contains numerous Chinese radicals and letters, symbols of our modern written languages and cultural achievements; however, the concept of this artwork extends beyond these symbols' immediate recognizability and should be understood in a broader context. According to Liu Jianhua, "While many artists express certain grand themes by narrative approaches or systems of symbols, I feel such communicative immediacy risks being shallow and want the opposite: to get rid of these so-called meanings and put more emphasis on the spiritual and perceptual experiences my works deliver."[3] In other words, this work is meant to be contemplative. At its core, *Collected Letters* is about interpretation, about the underpinnings of civilization, language, and art. Liu perfects his mastery of the visual language of sculpture and porcelain as a material so as to express an artistic sensibility that words cannot describe or exhaust.

There is great significance in the work's material: porcelain. *Collected Letters* can be considered an extension of the Chinese ceramics gallery in the Loggia. The gallery displays the technological and historical development of Chinese ceramics from the Song (960–1279) to the Qing (1644–1911) dynasties. Liu, who was trained in ceramic making from a young age, considers porcelain the most traditional and representative of Chinese arts. Indeed, China was the birthplace of porcelain—a high-fired vitrified translucent ceramic, which was, and to some extent still is, regarded as the most desirable and technically advanced ceramic in the world. From the fifteenth century onward, millions of Chinese porcelains were exported to Asia, Africa, and Europe, spurring an exchange of art and technology that remains unparalleled in world history. These exported Chinese porcelains were held in such high esteem in Europe that in the English language "china" became a commonly used synonym for the Franco-Italian term "porcelain."[4] This history of cultural exchange via the ceramic trade, immediately witnessed in the Asian Art Museum's Chinese porcelain galleries, is reimagined in the interplay of language and porcelain in *Collected Letters*.

Still, despite Liu's emphasis on the material, he considers himself not a ceramic artist but a contemporary artist who uses ceramics as his medium of choice. He says, "I meet many artists, whether ceramicists or painters, who feel the need to make their art about tradition, to define themselves by their chosen artistic media. Not me. I want to go beyond tradition, to use this inheritance [of Chinese ceramics] as a jumping-off point."[5] Liu prefers to disassociate himself from the clichés associated with the material and to concentrate on its conceptual possibilities and presentation. Part of his innovation as a contemporary artist includes his choice of untraditional subjects. Another factor is his consideration of his ceramic work as an installation in a specific space and context. According to Liu, "The more I work with porcelain, the more I discover its possibilities, especially as a perceptual vehicle in space that can somehow transport the viewer."[6] For the artist, ceramics form the building blocks of his own language of expression.

In the summer of 2015, with his proposal accepted and his concept in place, Liu Jianhua set about producing this complex installation from his studio in Shanghai. Before the actual production could begin, the artist and his team spent a considerable amount of time drawing sketches and making calculations to determine the weight and size limits of this installation, as well possible hanging mechanisms. After this preparatory work was complete, his studio began producing the actual ceramic pieces. Liu selected forty different Chinese pianpang radicals and fifty-two Latin letters (from both the lower- and uppercase alphabet). To allude to the Asian Art Museum's history as a library, he chose a serif font matching that used in the letters on the Loggia's lintels. He modeled the forms in three dimensions on the computer, used a computer-aided machine to cut out perfectly sized models in foam, then used these models to create the molds for casting the porcelain.

From this setup work done at his studio in Shanghai, Liu traveled to Jingdezhen, where he has his production workshop. Jingdezhen, a city in northeastern Jiangxi province, is known as the "porcelain capital" because it has been at the center of Chinese porcelain production for many centuries. With its natural deposits of porcelain clay (kaolin), it has the largest kilns for making porcelain in the world. Today, Jingdezhen artisans continue to manufacture porcelain based on ancient techniques. In his local studio, Liu has a trained team of twenty workers who assist him in various aspects of porcelain creation.

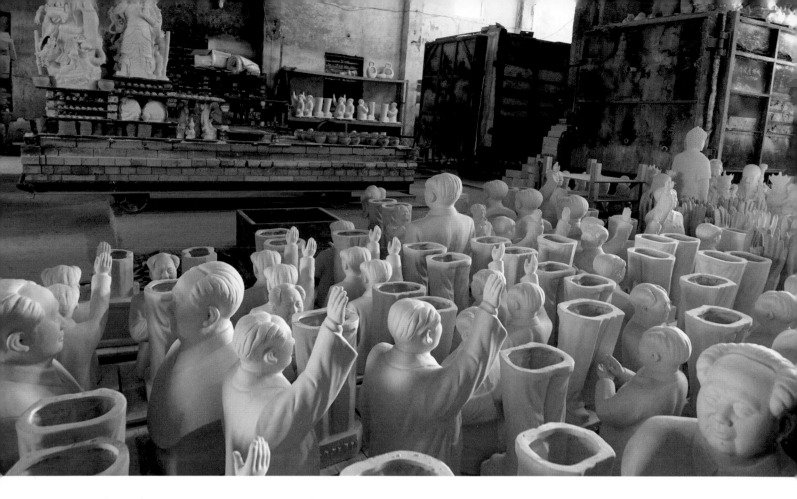

Porcelain sculpture at a ceramics factory in Jingdezhen, 2015

It took the artist's team over five months to complete the three thousand pieces for *Collected Letters*.

Each letter and radical is handmade in several steps: first the piece is slip cast from a plaster mold; it is removed from the mold; a hollow is drilled into it to allow a monofilament to go through it; the piece is dried; it is glazed white; and finally it is fired at 1,340° C (2,444° F). The artist noted several challenges in making this project: if a mold was opened at the wrong time, it was very easy to break a piece; if the dryness was not correctly gauged when the grooves were drilled into a piece, it would break or its shape would be affected; if the drying process was not constantly monitored, the pieces could change shape, given the wet weather conditions of Jingdezhen; and if each character's firing times were not precisely calculated (for example, an "m" needed more time than an "i"), it could rupture in the kiln. Nevertheless, given the risks and inevitable failed pieces, the artist said that he was surprised at how smoothly the process went. He credits the success to his and his team's careful preparation. By the end of 2015, the three thousand pieces were complete and ready to ship.

In March 2016, almost a year and a half after *Collected Letters* was initiated, Liu returned to San Francisco to install it. While the artist was busy with his part of the production, the staff of the Asian Art Museum had done much preparatory work as well. To install the work in the Loggia, a steel grid had to be set up overhead to hang the installation and to support its approximate 800 kilograms (2,000 pounds) weight. Since the Asian Art Museum is a Historic Landmark in the California National Register of Historic Places, the structural grid and lighting needed to be designed to ensure that there would be no damage to the original edifice, and special permits were required. Once approved, the grid and lights were attached to the ceiling support beams, and the ceiling was painted to disappear as much as possible into the surrounding walls. With the space ready, Liu Jianhua and an assistant, together with four museum preparators, hung *Collected Letters*. Working from the center to the periphery, over several days, the team fastened each letter and radical with transparent monofilament. To ensure an adequate selection, Liu overestimated the number of letters needed, and ultimately some 1,600 pieces were suspended to achieve the final effect.

There are some artworks that are transformative and timeless and can be truly experienced only if viewed in person. I believe that *Collected Letters* falls into that category. You get a different perspective of the artwork, placed in the corner of the museum Loggia, when viewing it from the grand staircase, the U-shaped Chinese ceramic gallery balcony, or the main entrance to the second-floor exhibitions hall. Suspended as they are in an elaborate beaux arts room, lit so that their white glaze has an almost ethereal halo, these porcelain pieces seem to float between eras and between worlds. Here the art and space seem so inexorably linked that they tell the work's story together. The artist says that if there comes a day when, by chance, a piece falls to the floor, "Don't pick it up! If a piece breaks, or there is an earthquake and pieces come off, to me, this is part of the process of the work as it continues to change in the environment. I think it is these factors that make the work more interesting."[7] Although this piece like every other in the museum has been assessed and installed to deal with local seismic conditions, there is still an element of surprise here. Fragile and challenging, a combination of ancient technique and contemporary presentation, *Collected Letters* extends the history of Chinese ceramics of the ceramics

gallery that surrounds it into a modern conceptual realm. Each radical and letter is glazed pure white because the artist would like viewers to bring their own imaginations and interpretations to this installation—to read and see what they want from it. According to Liu, "I'm not interested in creating a straightforward, clear-cut piece. This work is better if people take the time to think about it....I am just leaving the building blocks; it is for them to construct their own meaning." The interactive nature of *Collected Letters* makes the installation space and its audience part of the creation.

There is one additional detail of this artwork that should be addressed, and that is its title. In Chinese it is 混合体 (*hunheti*), which can be directly translated as "hybrid"; however, there is more to it than that. The first two characters, 混合, mean "to mix," and 体 means "body" or "form." 体 is a character that is often used with 字 (*zi*), the character for "character"; 字体 (*ziti*) is a way of saying "typeface" or "letter." In other words, the Chinese title is a kind of play on words that has to do with language, letters, and putting things together, which is literally what Liu is doing in his installation. Since much of this significance is lost in translation, an alternative, less literal, English title was adopted. *Collected Letters* was suggested by Karin Oen, Assistant Curator of Contemporary Art at the Asian Art Museum, who brainstormed with the museum team. Also a play on interpretations, here "*Collected Letters*" is a direct reference to the installed collection of porcelain letters Liu has produced. In addition, as individual words, "collected" might refer to the diverse components brought together from various sources, in this case the building blocks of Chinese and English words. "Collected" is also an important word used for both museums and libraries and the artworks, artifacts, and books that they bring together. Another connotation of the word "collected" is "calm" or "composed," which describes the contemplative and peaceful tone in libraries and museums, as well as the spirit of this installation. Lastly, in the English title there is also a double meaning in "letters," signifying the letters of the alphabet or letters written from one person to another to communicate across time and distance. In both English and Chinese the title is open-ended and offers multiple significances.

Collected Letters is both a hybrid of different ideas and a collected work of art. Starting with the most basic components of Western and Chinese words, Liu Jianhua has created a site-specific artwork that resonates with museum viewers through its many connections:

to tradition, to contemporary conceptual art, to Chinese ceramic culture, to the diversity of San Francisco, to the architecture and collection of the Asian Art Museum, and to the artistic and literary achievements of humanity. Given our globalized world, some critics argue that contemporary art is increasingly homogenized; Liu's *Collected Letters*, however, lays out a pluralistic idea of what constitutes art in the twenty-first century. It suggests that artwork can be multifaceted and still retain elements that are both distinctly Chinese and universal. The arts, like language, employ imaginative and intellectual capacities that have emerged in similar forms across cultures. But unlike language, art is cross-cultural: Beethoven is loved in Kenya, Japanese prints are collected in France, and Shakespeare is enjoyed in China. Likewise, the premier collections of the Asian Art Museum of San Francisco are a testament to the enduring appreciation and fascination we have for the aesthetic achievements of Asian art and culture. As the museum celebrates its fiftieth anniversary, the timeless artwork *Collected Letters* reminds us of the universal power of art to evoke, excite, and inspire.

1 Liu Jianhua, WeChat conversation with the author, January 9, 2016.
2 K. C. Chang, *Art, Myth, and Ritual: The Path to Political Authority in Ancient China* (Cambridge, MA: Harvard University Press, 1983), 81.
3 Liu Jianhua, conversation with the author, Shanghai, September 20, 2015.
4 Robert K. G. Temple, *The Genius of China: 3,000 Years of Science, Discovery, and Invention*, 3rd ed. (London: André Deutsch, 2007), 104–5.
5 Liu, conversation, September 20, 2015.
6 Ibid.
7 Ibid.

CREATING COLLECTED LETTERS

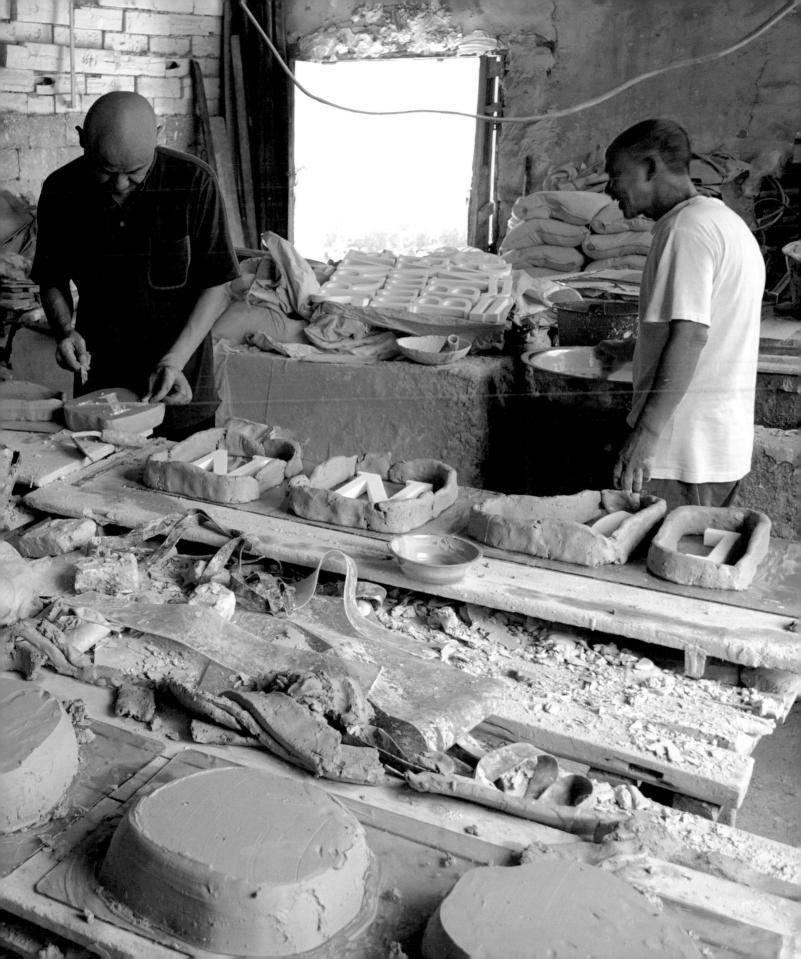

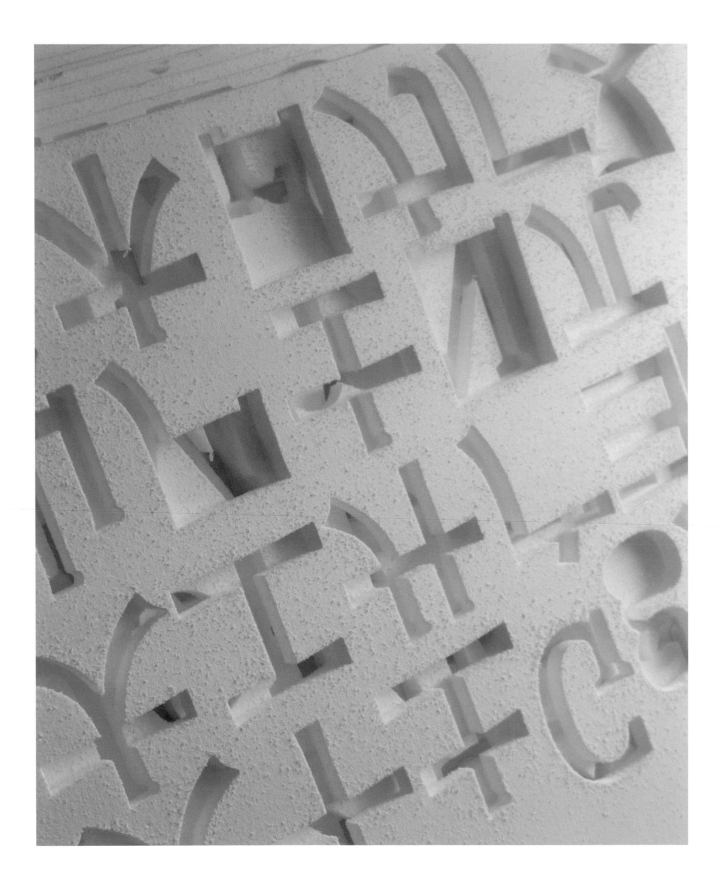

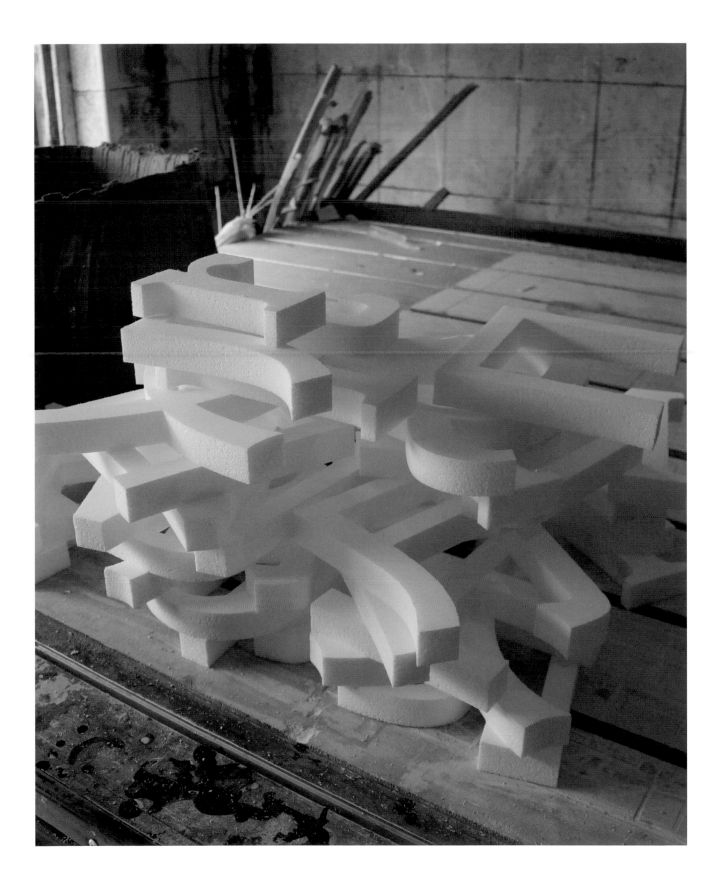

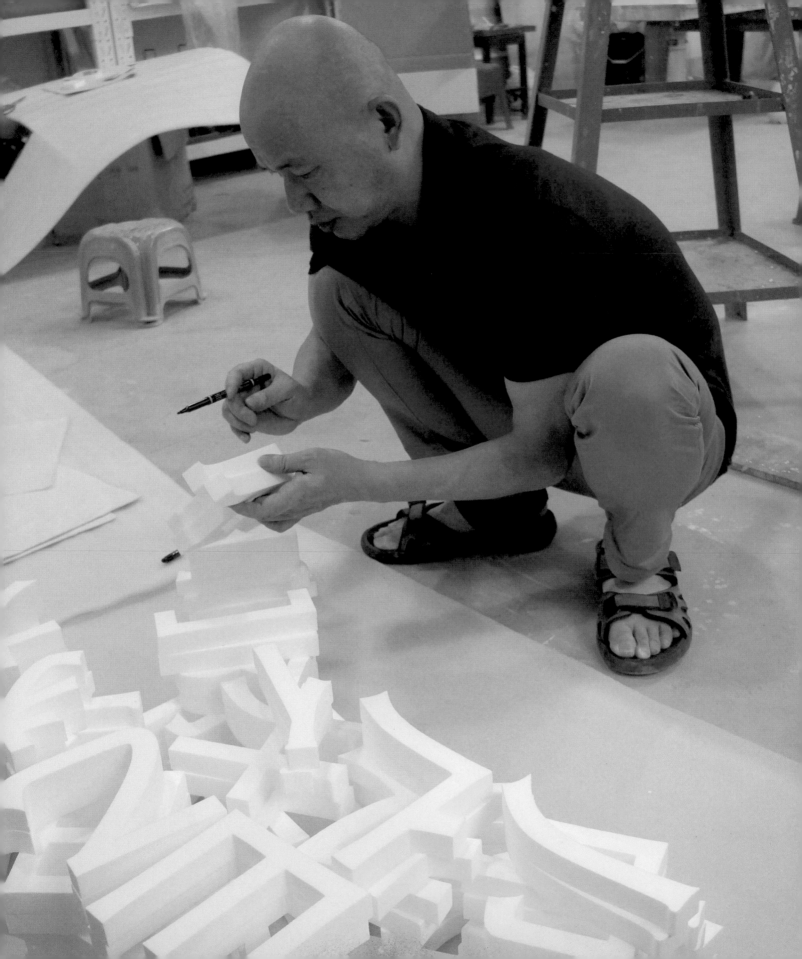

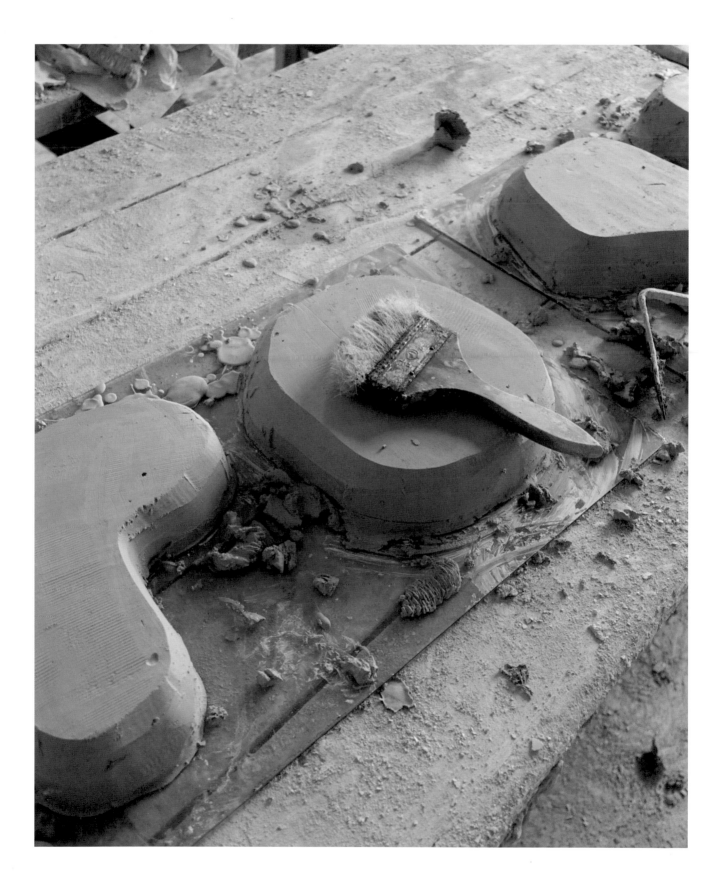

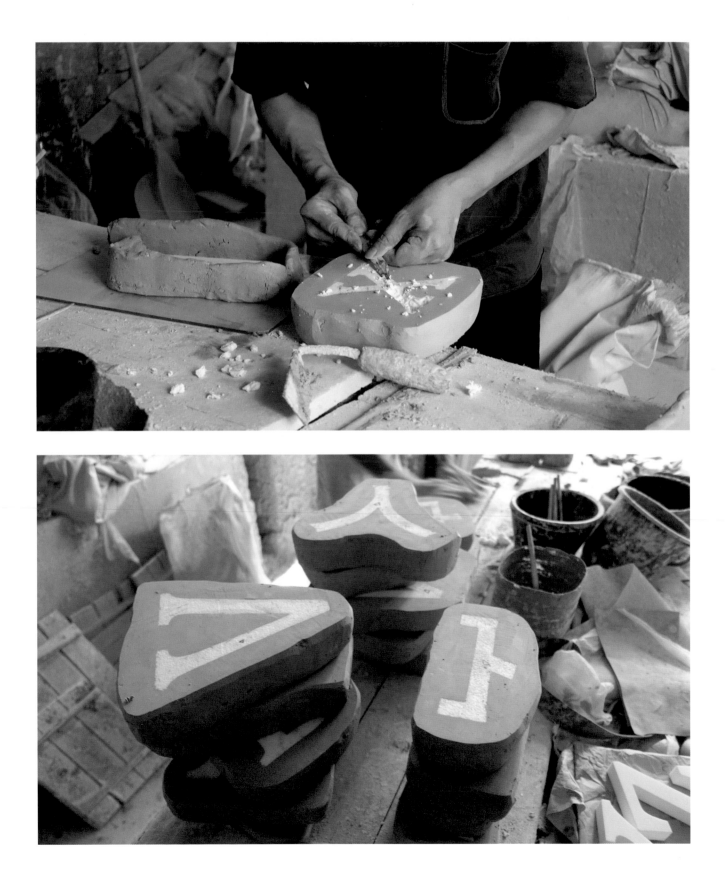

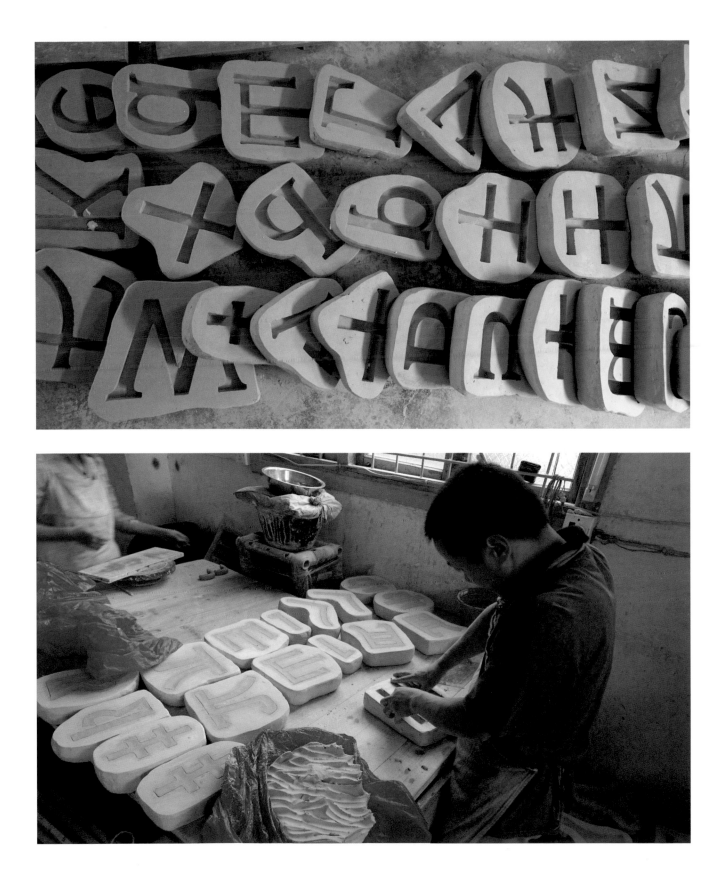

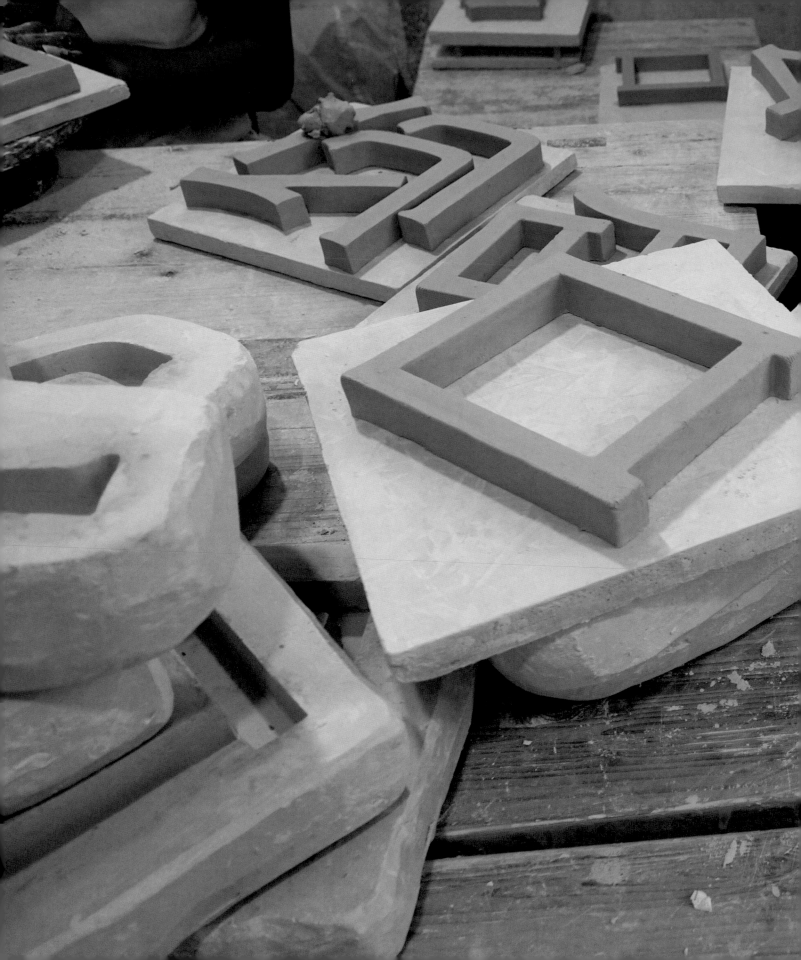

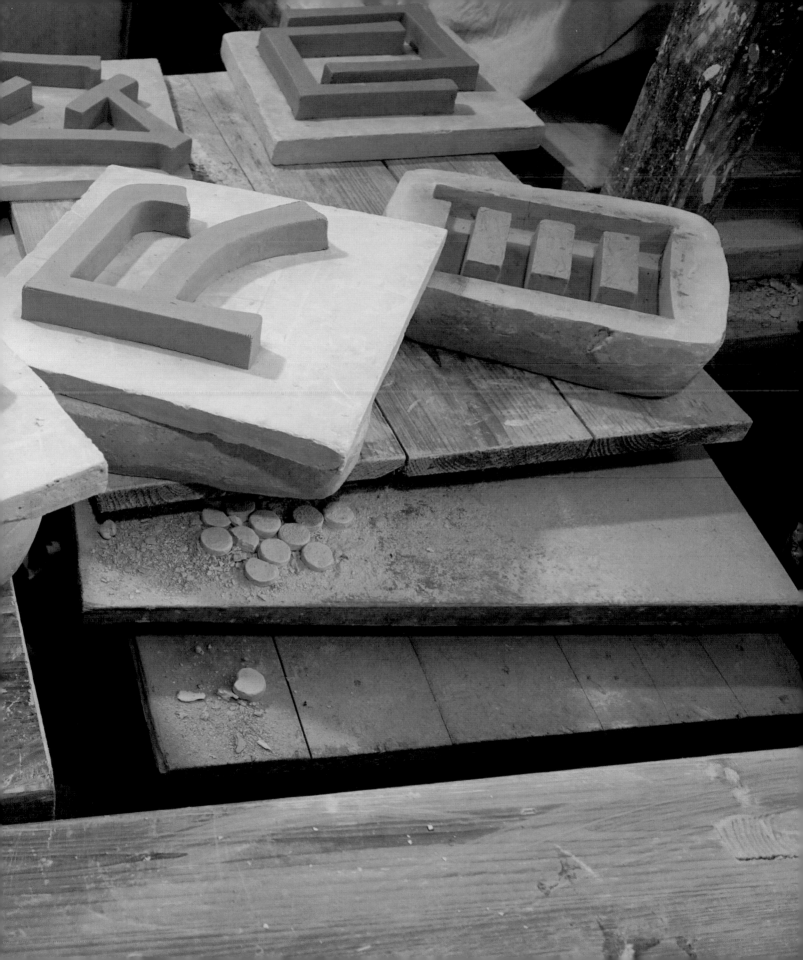

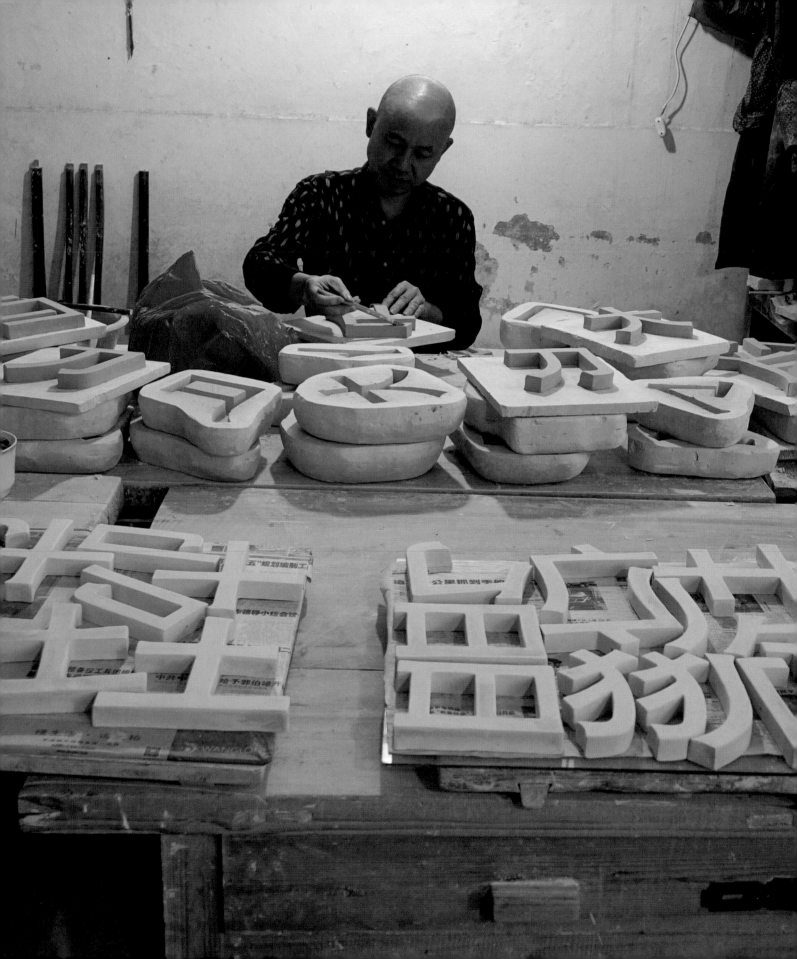

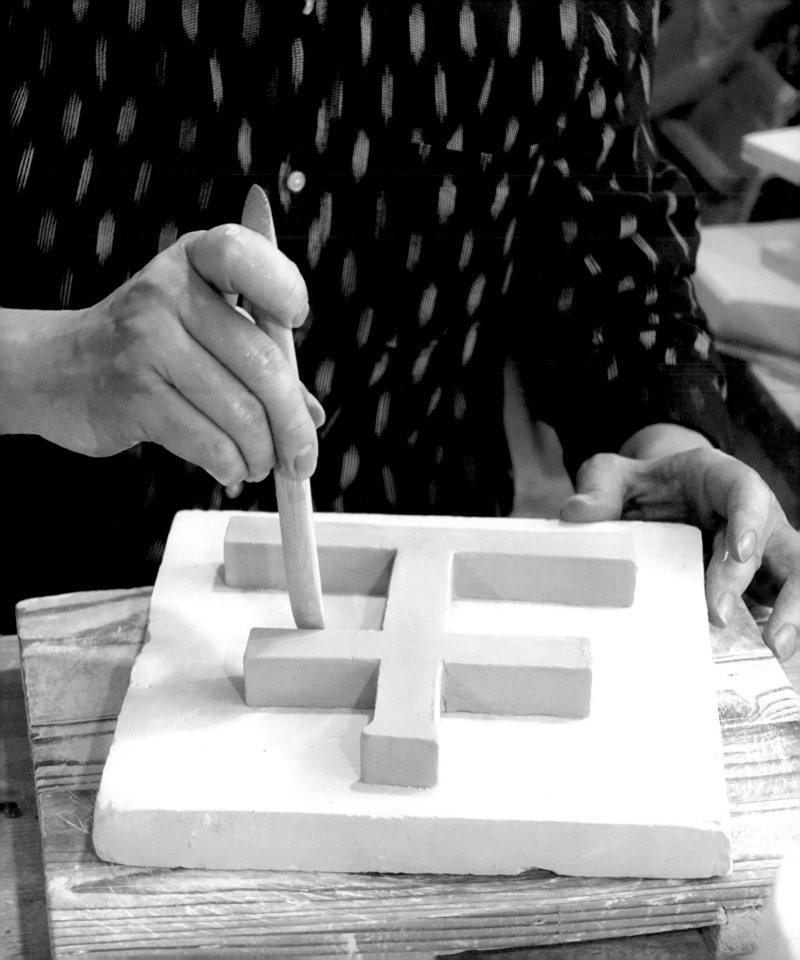

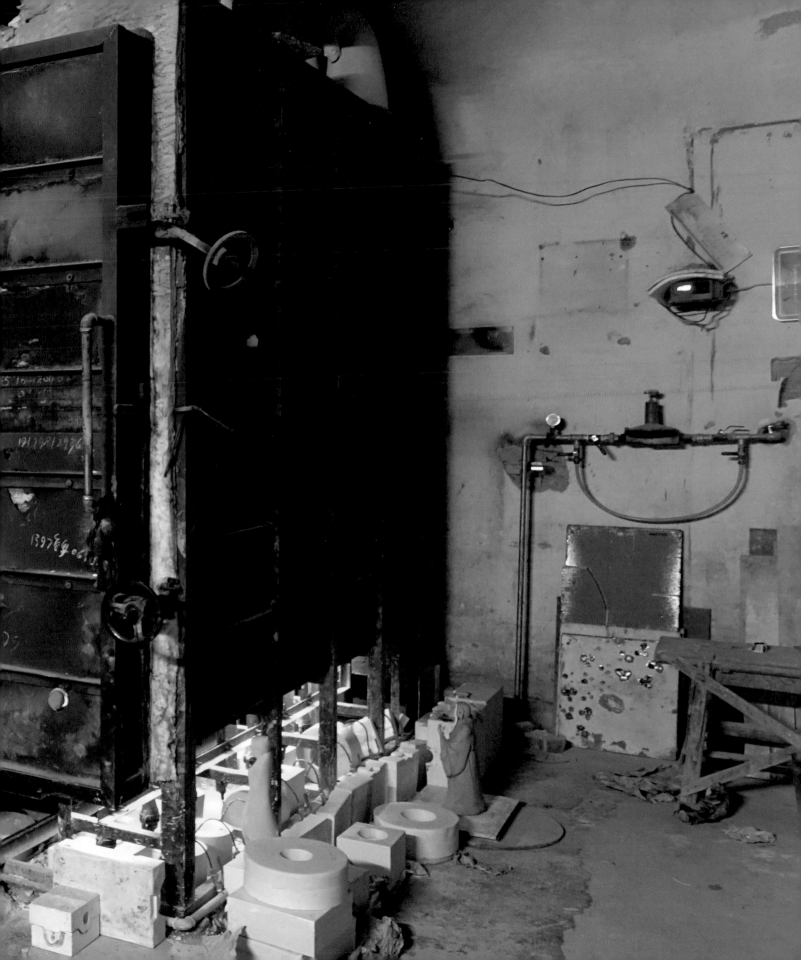

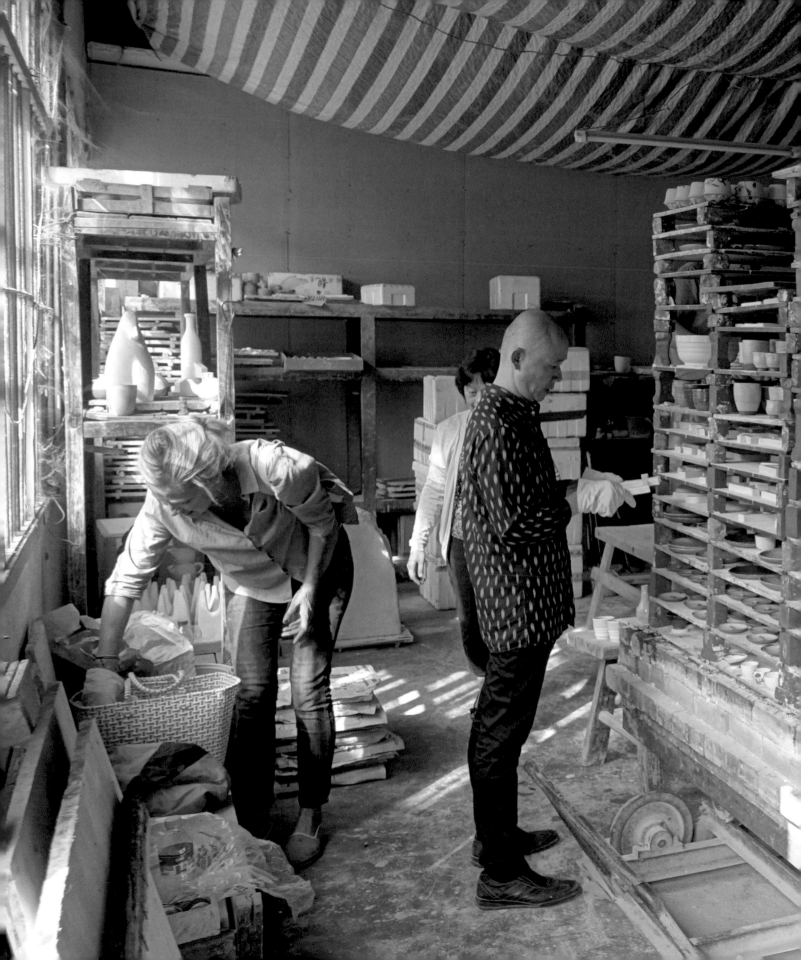

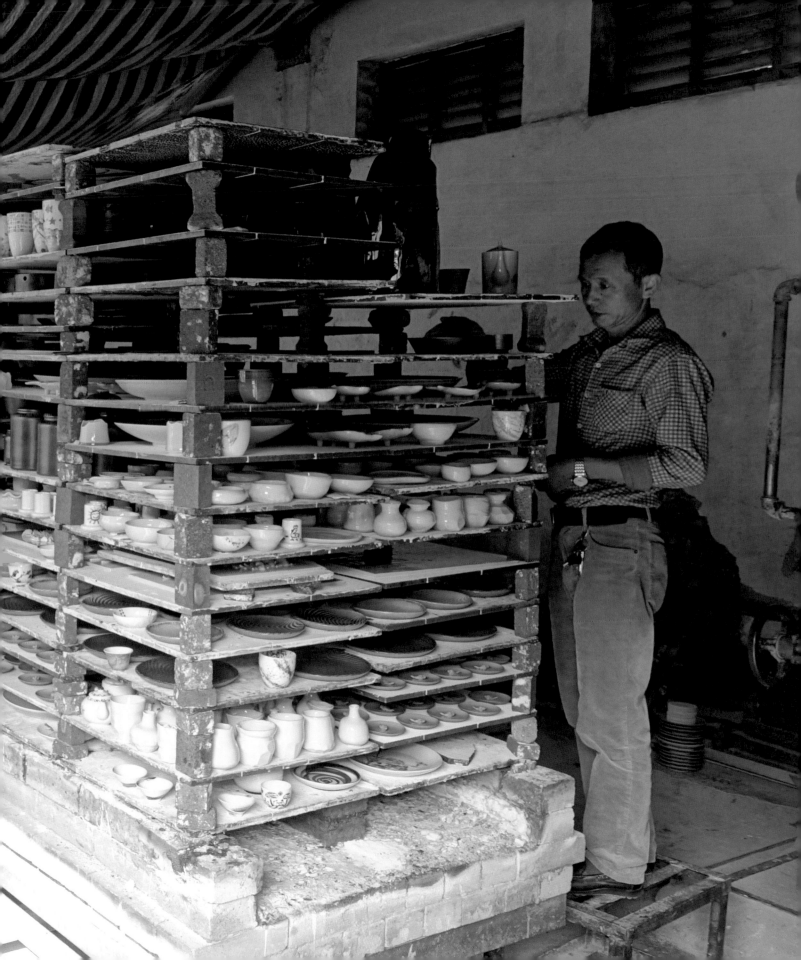

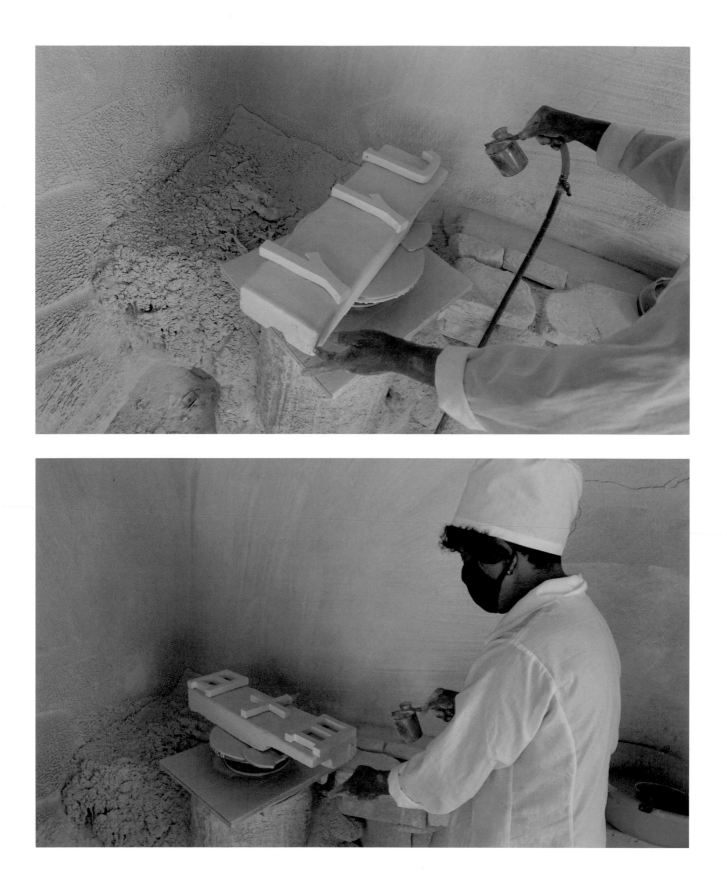

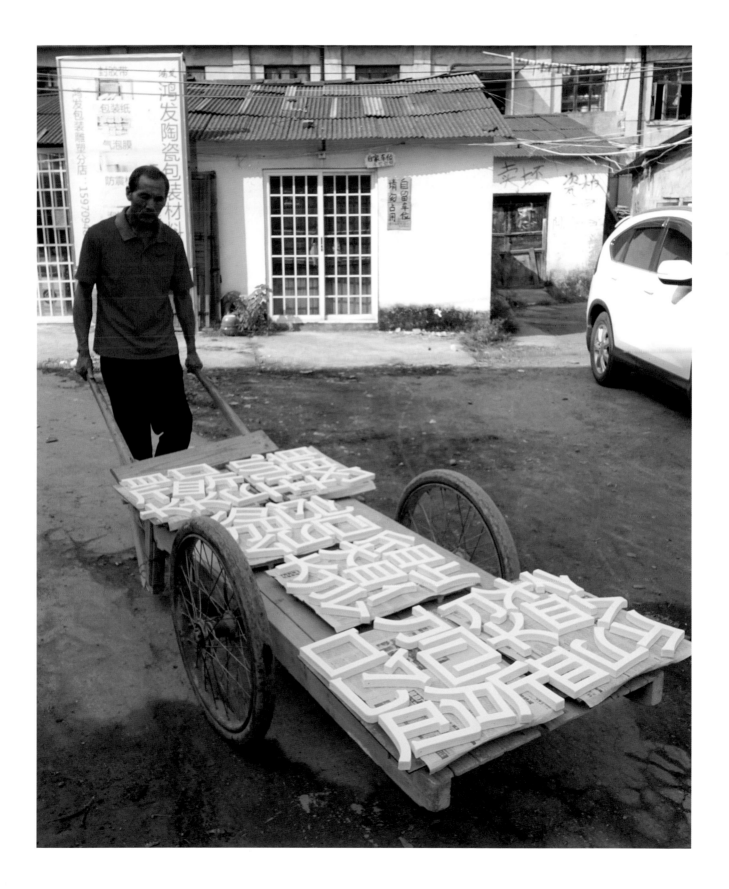

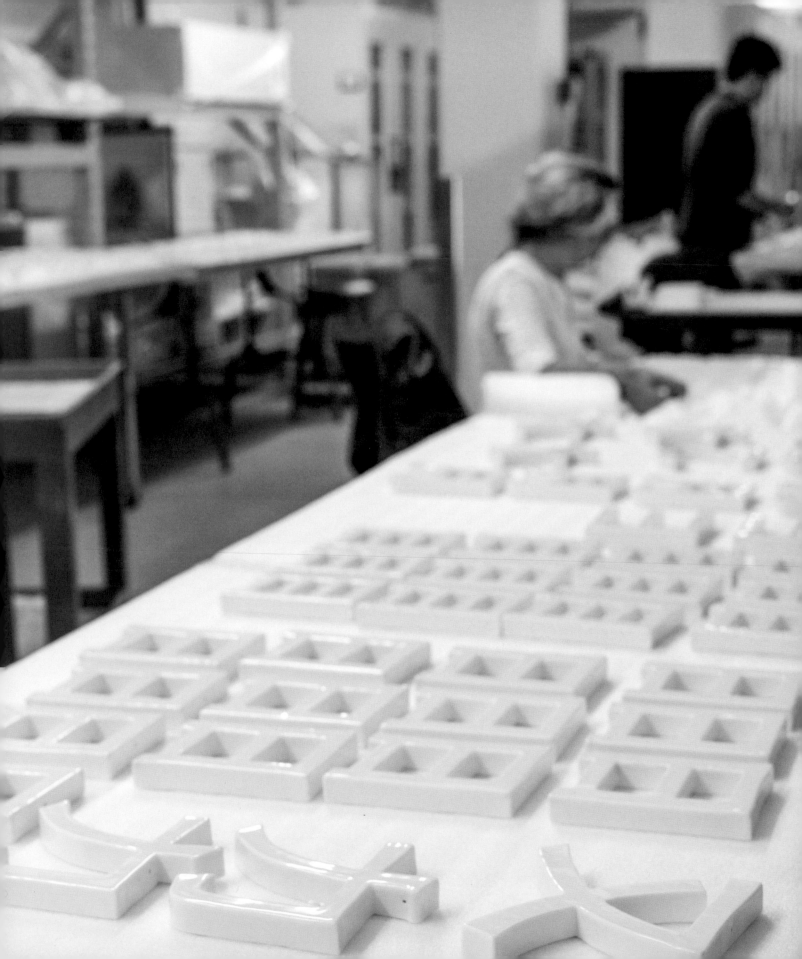

LIU JIANHUA: MEDIUM AND METHOD

KARIN G. OEN

I have always believed that any material at one's fingertips could be made into the medium and method for one's artwork. However, what is critical is whether or not one uses it to express one's own ideas.

—Liu Jianhua, "On Painted Sculptures"

Collected Letters is a study in the unity of differences. English and Chinese. Old and new. Tangible and ephemeral. Accessible and esoteric. Reverence for the past and exploration of new, uncharted territories. Its comingled, suspended, white porcelain forms—the letters of the Latin alphabet and the radicals that form Chinese characters—are the building blocks of language and communication, yet in this installation they never come together to form readable words. They are the deconstructed complements to the books that filled the Asian Art Museum building when it was San Francisco's Main Public Library. Wise, anonymous maxims inscribed on the upper lintels of the Loggia remain as reminders of the building's former life. This new assemblage of white radicals and letters nods to the past while presenting tempting possibilities for yet-to-be-written prose and poetry.

Taken out of their utilitarian context in words or sentences, letters and radicals can be seen as sculptural compositions in their own right. The graceful curve of a lowercase "e" or the pleasing symmetry of the radical "口" (*kou, mouth*) can be appreciated with fresh eyes. Simple, familiar shapes are made new again. Unfamiliar shapes, to those not literate in both English and Chinese, are made more approachable. They are simultaneously plain and lustrous. This beautiful illegibility is refreshing to modern eyes that are so accustomed to an overabundance of unedited text. It is this type of powerful resonance with the world we live in, nostalgia for a world that once was, and hope for a world that might be that reveals the depth of this deceptively simple artwork and the skillful hand of the artist Liu Jianhua.

An internationally renowned contemporary artist, Liu Jianhua has created many intriguing and appealing works comprising beautiful forms made strange by their scale,

material, color, or placement. His works, even those designed to trouble viewers' sensibilities, are seductive in their execution. Liu's early installation work in porcelain included renderings of female bodies, missing heads and arms, surrealistically presented in beautiful *qipao* dresses and reclining on fine dishes, chairs, or bathtubs. Other work involved masses of everyday objects like books, toys, tools, and shoes rendered in stark white porcelain, intermingled with porcelain miniatures of slightly more sinister tanks, guns, and fighter jets. Arranged in various configurations, these objects have been installed on floors to evoke dystopian cityscapes, suspended from the ceiling to create a floating world, or incorporated into existing rooms as ghost-like surprises in otherwise predictable environments. These projects have been well documented and appreciated for their visual and phenomenological impact on viewers. What is less understood is Liu Jianhua's particular importance as a cultural intellectual. His artistic practice was formed by the intersecting histories of Chinese porcelain, fine arts training in modern China, and the intellectual reawakening of China's Reform Era (1978–present). This text attempts to expose these complicated and layered influences, starting with the alluring material of porcelain and its significance in Liu's story.

China/china

The porcelain alphabet and radicals of *Collected Letters* are completely at home in the Asian Art Museum, an American institution with one of the most significant collections of Chinese porcelain in the world. The connections between this new work and the historical pieces on view nearby it go beyond their material, although the simple beauty of fine porcelain serves as an alluring starting point in much of Liu's work. The production of porcelain from fine kaolin clay augmented with ground baidunzi stone, fired at a high temperature to create a strong, light, and almost translucent ceramic, is part art, part science, and part alchemy. The magic embedded in this potentially prosaic earthen material comes in the high degree of refinement of technique that spurred a global appetite. The stuff of imperial manufactures, at home in the studios of austere Confucian scholars, courtly assemblies from Nanjing to Nishapur, and fashionable European palaces alike, porcelain is so closely affiliated with the culture of China that it became synonymous with it.

The histories of the art of porcelain and trade ceramics are an important conarrative to Liu Jianhua's biography and career trajectory. Liu was born in 1962 in Jiangxi province and moved to Jingdezhen at the age of twelve to study with his uncle Liu Yuanchang, a successful industrial artist (now designated a national master) working in the traditional métier of porcelain sculpture. At fourteen, Liu Jianhua was accepted as an apprentice at the Jingdezhen Ceramics Factory, where he worked for the next eight years learning the artisanal, technical, and practical aspects of that field. This deep connection to the production of traditional porcelain continues to factor into Liu Jianhua's work, as is evident in many of his installations, including *Collected Letters*. It is an important point of difference between his and his contemporaries' (who have only fine arts training) methods of working. And it is a significant factor in the creation of his laborious, multifaceted installation projects. Another crucial conarrative is the larger story of avant-garde art in twentieth-century China, and the role of China's art schools in the making of an avant-garde.

An Official Road to Unofficial Art: Academies in Twentieth-Century China

At the beginning of his tenure at the Jingdezhen Ceramics Factory, Liu Jianhua came across a monograph on the work of Auguste Rodin (1840–1917) at his uncle's house. Inspired by the expressive sculpture in the tome, Liu continued to develop an interest in global art and history while he honed his technical abilities at the factory. In 1982, while still working at the factory, he received a Hundred Flower (*Bai hua*) Award, China's top commendation in literature and the arts. This kind of official accolade was an important feather in one's cap for anyone, like Liu, who aspired to go beyond the industrial arts of the ceramics factory and train in an elite art school. Liu and his generation had grown up during the Cultural Revolution (1966–1976), when most institutions of higher learning were closed. In the 1980s these newly reopened colleges faced a glut of students hoping to gain one of the coveted few places. In 1985, Liu was one of only two students from Jiangxi province admitted to the Jingdezhen Ceramic Institute, where he enrolled as a sculpture major.

The Jingdezhen Ceramic Institute was founded in 1909 as a specialized institution focusing on the Chinese art of porcelain. By the 1980s it had become part of the system of Chinese art schools and offered a fine arts coursework that incorporated elements of

European academic curricula. In the early Reform Era, when Liu attended the institute, Chinese art schools were remarkably faithful to their pre–Cultural Revolution courses of study and ignored postmodernism and other contemporary art movements. However, these schools were important assembly sites for bright students in search of something more, carried out in unofficial reading groups focused on previously banned or newly available material.

Students like Liu, inclined toward unofficial artistic experimentation, occupied two worlds. The first was that of mainstream achievement and technical prowess within the official curriculum. The second was the liminal realm of intellectual and artistic freedom, including considered criticism. This realm was unofficial but largely tolerated, as outlined in Deng Xiaoping's call for a rapprochement with China's elite in the Reform Era. At the Fourth Congress of Writers and Artists in 1979, Deng addressed these issues directly:

> Party committees at all levels should give good leadership to literary and art work. Leadership doesn't mean handing out administrative orders and demanding that literature and art serve immediate, short-range political goals. It means understanding the special characteristics of literature and art and the laws of their development and creating conditions for them to flourish.[1]

The "Beijing Spring," as China's early Reform Era (particularly 1978–1979) is known, has been described as a thawing, awakening, and emerging from hibernation. Extending the seasonal metaphor, 1980s China has been described as a time of intellectual flowering. These terms have been applied to the nation's economy and its political relationships with the outside world, but neither opening would have been possible without the simultaneous reinvigoration of China's cultural realm. The political scientist Edward X. Gu employs the term "cultural intellectuals" to refer to Reform Era thinkers who concerned themselves with large questions pertaining to the human condition regardless of disciplinary boundaries.[2] This term applies to many artists of the '85 New Wave and is particularly appropriate for Liu and the socially engaged work that he has pursued in the three decades since 1985.

The '85 New Wave

Given Liu Jianhua's early interest in the fine arts and accomplishments in the realm of decorative porcelain sculpture, it is unsurprising that he evolved from an industrial artist to a sculptor and, later, to an installation artist. At the age of twenty-two, as the '85 New Wave continued to pick up speed in cities around China, Liu began his studies at the Jingdezhen Ceramic Institute. While this institution was not the epicenter of the avant-garde art experimentations percolating around the country, it allowed for Liu to expand his worldview and art practice. Looking back at this period fifteen years later, the artist summarized this transition and his desire to distance himself from porcelain:

> I wasn't yet 15 when I went to work in a famous porcelain factory in Jingdezhen, where I learned the art of making ceramics and how to create sculptures of traditional figures. Later, I grew tired of it because I felt it wasn't really art. After 8 years of working there, I won a place at the academy to study sculpture. At the time, I took a particular interest in realism which I felt was real art, and I was certain that I could never go back to using the materials I had used in the past.[3]

To grow beyond the ceramics studio, Liu Jianhua looked to the past, to foreign sources, and to the art happenings around China. While studying at the institute, he voraciously consumed the many arts journals being published across China. Through these magazines, he learned about contemporary art in all its forms. This included early Reform Era art groups such as the Stars Group, the No Name Painting Society, and the April Photography Society, all of which had their first exhibitions in 1979, arguably the founding exhibitions that ushered in a new era of avant-garde Chinese art.

These publications documented new experimental art practices, group manifestos, and exhibitions, and reported on modern and contemporary art from abroad—material that had been completely inaccessible during the years of the Cultural Revolution. The journals, magazines, and occasional periodicals were produced largely by young artists and recent graduates of colleges, universities, and art academies that had reopened in the late 1970s and early 1980s. These schools were significant not just for their formal art

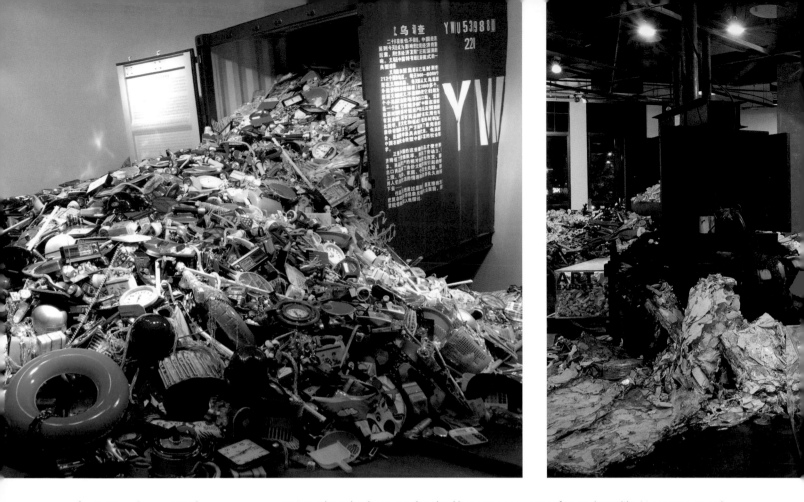

fig. 1 *Yiwu Survey*, 2006,
installed at the Shanghai
Museum of Art

fig. 2 *Export–Cargo Transit*, 2007,
installed at the Shanghai
Gallery of Art

training but also because they had become conveners for students like Liu, young people swept up in the phenomena of "Culture Fever" and "Reading Fever" inside and outside formal academic institutions.

Many innovative avant-garde artists graduated from art academies in the early to mid-1980s, with 1985 as a watershed year for art in China. The term "'85 New Wave" was a near-simultaneous historicizing of these events, exhibitions, and artistic experimentations. The fact that Liu began his academic studies in 1985 ties him inexorably to this era. His work, however, evolved somewhat outside the crucibles of contemporary art in the 1980s—Beijing, Shanghai, Guangzhou, Hangzhou, Xiamen, and Xi'an. Liu benefited from a modicum of hindsight and distance from these centers, first in Jingdezhen and later in Kunming, where he was on the faculty of the Yunnan Arts University from 1989 to 2004. This is not to say that he was out of reach of the influence of his peers, but that his participation in the avant-garde was simultaneously purposeful and selective.

To understand the importance of Liu's evolution from porcelain artist to avant-garde installation artist and cultural observer, one needs to understand the zeitgeist of the '85

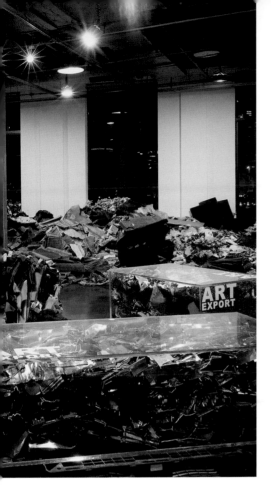

New Wave. At a 1986 conference in Zhuhai, the art historian Gao Minglu described the art of the '85 New Wave as spontaneous and self-organized, group oriented, rebellious, experimental, and influenced by Western modernist forms.[4] Gao's attempt to characterize the artistic activity of just a year as a movement is an example of the savvy and self-consciousness of the artists at work in 1980s China. They were well aware of the traditional infrastructure of the art world in the West, as well as the official institutions in place in the People's Republic. They naturally created a version of these same institutions including exhibition venues, conferences, and publications, albeit in an appropriately rebellious, experimental manner.

Exports, Imports, and the Politics of Form

Following the heady years of the '85 New Wave were several decades of growth of avant-garde art in China. Over the 1990s and 2000s, Liu Jianhua's art practice expanded considerably. The artist's relationship to medium and genre had become one of considered discontinuity. His approach allowed for openness, experimentation, and bold risk-taking. He created works in many mediums and materials, including everyday objects and manufactured goods, video, photography, fiberglass, and steel.

A few themes run through this body of conceptual work, most notably critiques of collective and personal memory; the rapid economic development of China (in particular the city of Shanghai); and the costs in human health associated with economic success and urban expansion. Especially since moving to Shanghai in 2004, Liu has assumed an artistic identity of cultural intellectual as flaneur: an urban citizen who takes in his surroundings and observes the behavior of the masses, a figure in the crowd but not of the crowd.

To understand *Collected Letters* as part of this diverse body of work, consider two projects that might seem the farthest from his works in lustrous porcelain: *Yiwu Survey* (2006) and *Export—Cargo Transit* (2007).

In *Yiwu Survey* (fig. 1), Liu Jianhua examined the mountains of commodities, mostly cheap plastic goods, manufactured or purchased in Yiwu, Zhejiang province, home to China's largest wholesale marketplace and source of a thousand containers of goods shipped per day. He installed thousands of these bright, flimsy goods cascading out of an

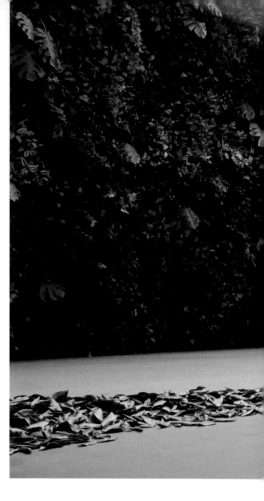

fig. 3 *Trace*, 2011,
installed at the Ullens Center for
Contemporary Art, Beijing

fig. 4 *Fallen Leaves*, 2012,
installed at the Aurora Museum,
2014, Shanghai

open shipping container in a gesture examining accumulation, excess, and disposability. In 2006, when *Yiwu Survey* was shown at the Sixth Shanghai Biennale, the world was transfixed by China's economic growth. Liu's description of the work touches on not only the world economy but also its ramifications for how we live today:

> It is these cheap goods from China that decrease the global inflation and alter the relative prices of labour, capital, goods, and assets. The cheap exported goods offset the price increases caused by the skyrocketing oil prices, and thus they correlate with societies, families, and individuals.[5]

The following year, Liu created *Export—Cargo Transit* (fig. 2), an installation of Plexiglas boxes labeled "art export" that contain compressed, baled industrial trash from Western countries. This site-specific installation took place in a gallery space on the historic Bund, Shanghai's former financial center, overlooking the Huangpu River and the skyscrapers of the Pudong New Area. The fraught history of Shanghai's relationship with the West

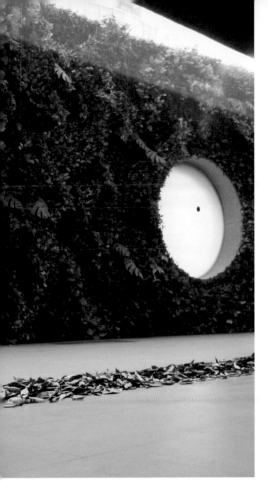

resonated with the artist's social message and savvy references to minimalist sculpture and monumental installations.

With both of these works, we see Liu's willingness to cede some control of the artistic process by incorporating found objects and other materials from outside the realm of fine arts and creating environments that are far from rarefied. In both he masterfully creates the conditions for dialogues on social and environmental issues that are at the core of his practice, in no small part by the care and attention he gives to mundane materials.

Liu Jianhua's continued engagement with installations has brought him back to porcelain again and again, but not because of a slavish attachment to that material. Rather, it is because his particular combination of artistic vision and technical ability allows him to realize the potential of this flexible medium in a way that few others can. *Collected Letters*, like several of his recent porcelain installation works including *Trace* (2011, fig. 3) and *Fallen Leaves* (2012, fig. 4), is a synthesis of Liu's attention to history, to space, and to the continuous exploration of art as a means of engagement across time and place. Liu has said, "It is my hope that when people see my work, they will feel an inner rush and a sense of awakening."[6] It is with this genuine hope to touch minds and hearts that Liu continues to mine the history, culture, and beauty hidden just below the surface, or in some cases, inscribed just above our heads.

1 Deng Xiaoping, "Speech Greeting the Fourth Congress of Chinese Writers and Artists (October 30, 1979)," *People's Daily*, http://english.peopledaily.com.cn/dengxp/vol2/text/b1350.html (accessed October 13, 2009).

2 Edward X. Gu, "Cultural Intellectuals and the Politics of the Cultural Public Space in Communist China (1979–1989)," *Journal of Asian Studies* 58, no. 2 (1999): 390.

3 Liu Jianhua, 1996, quoted in Pi Li, "Polychrome Ceramics, Cheongsam, and Chinese Porcelain," in *Liu Jianhua, Porcelain-Like Skin* (Hong Kong: Hanart T Z Gallery, 2000), 17.

4 Julia F. Andrews, "Fragmented Memory: Introduction," in *Fragmented Memory: The Chinese Avant-Garde in Exile*, ed. Julia F. Andrews and Gao Minglu (Columbus, OH: Wexner Center for the Arts, 1993), 10.

5 Liu Jianhua in Liu Jianhua, Edwin Zwakman, Zhuan Huang, Monica Dematté, Mathieu Borysevicz, and Yusha Li, *Yi qi = Discard* (Shanghai: Shanghai Pujiang Overseas Chinese Town Public Art Project, 2011), 72.

6 Liu Jianhua, 1998, quoted in Pi, "Polychrome Ceramics," 19.

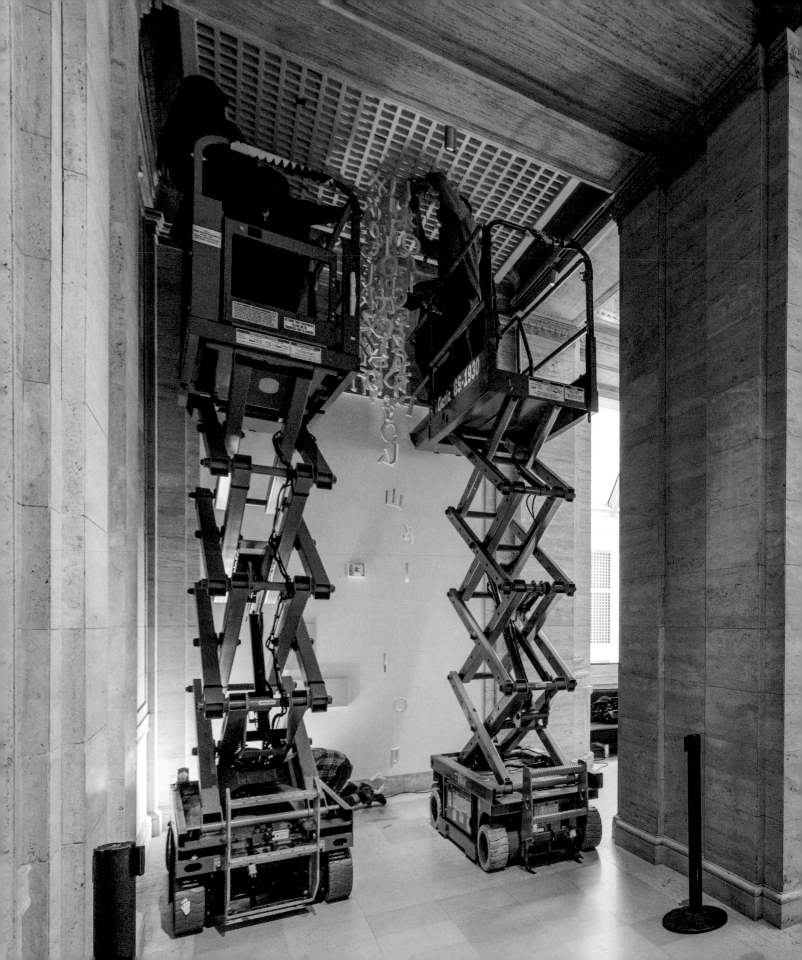

INSTALLING COLLECTED LETTERS

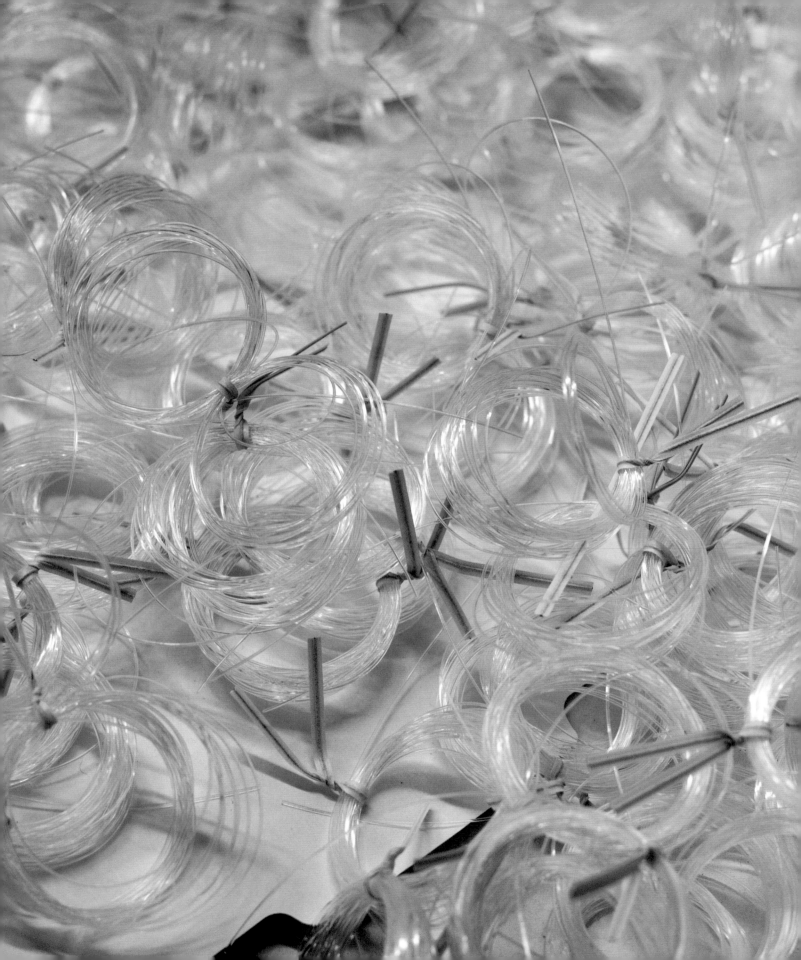

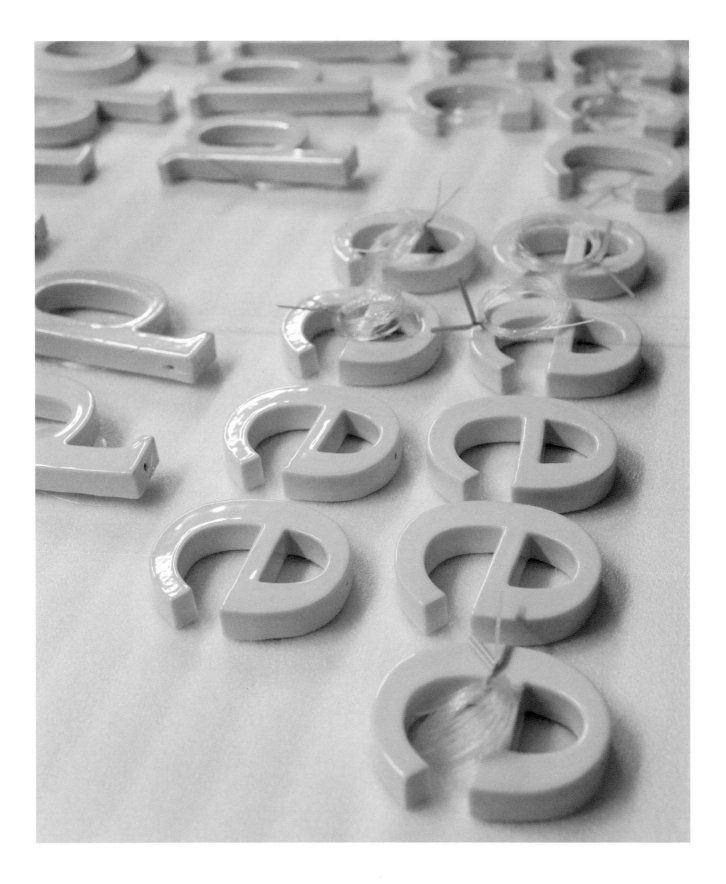

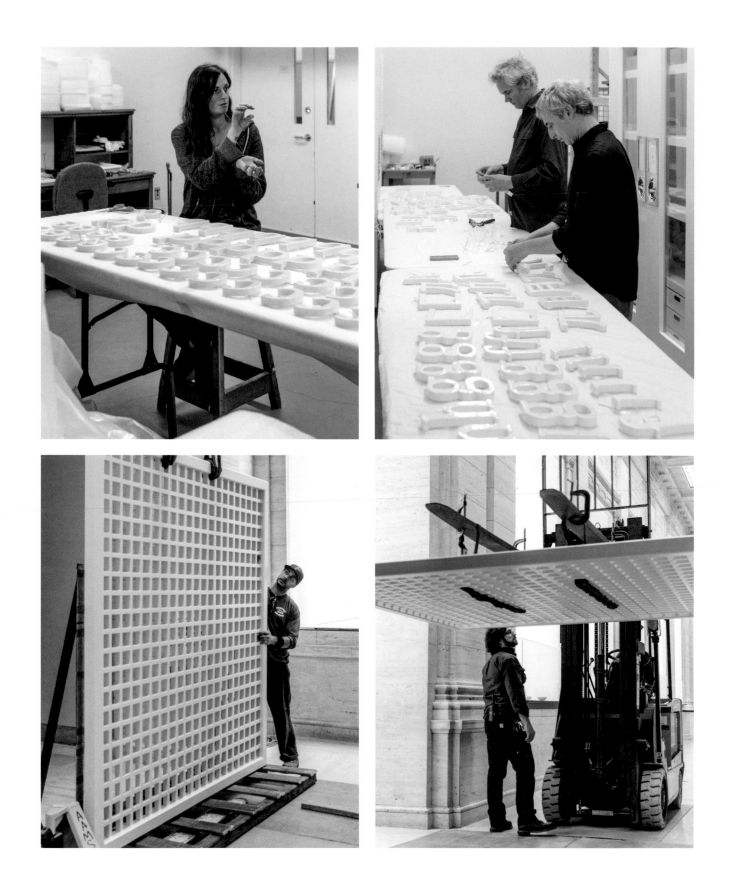

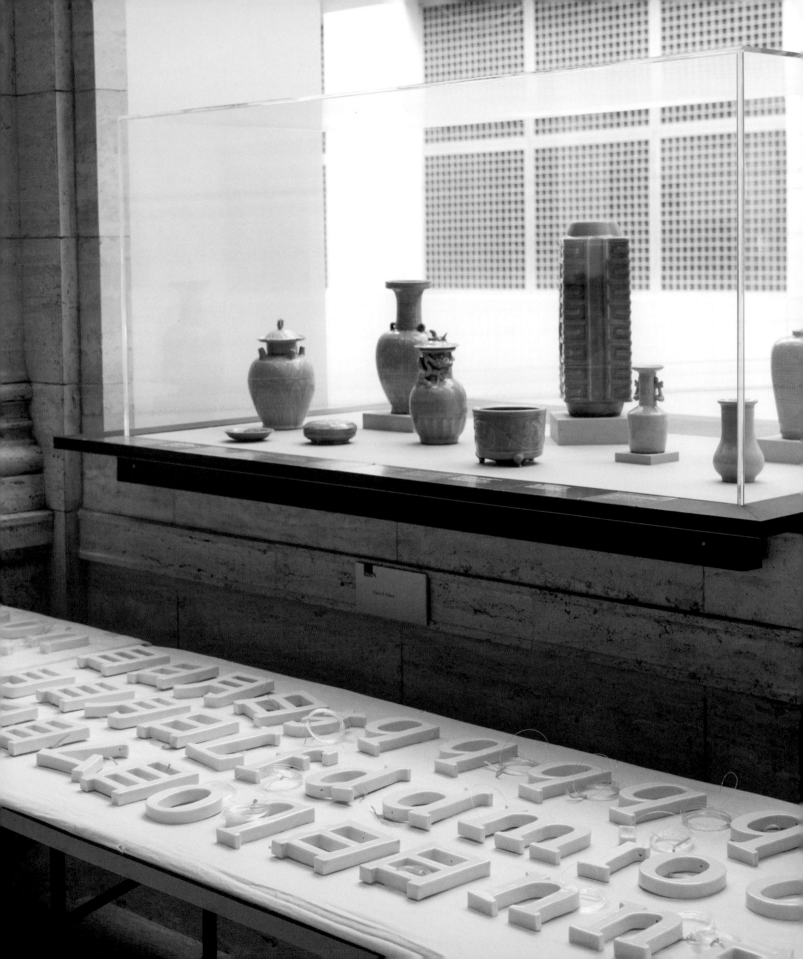

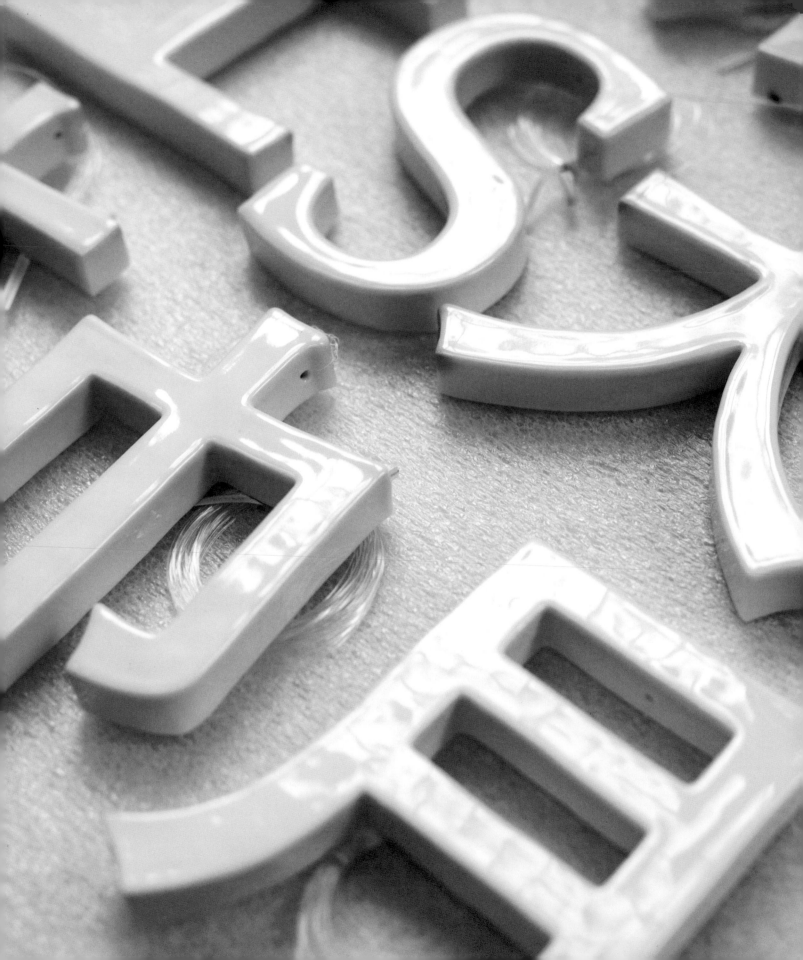

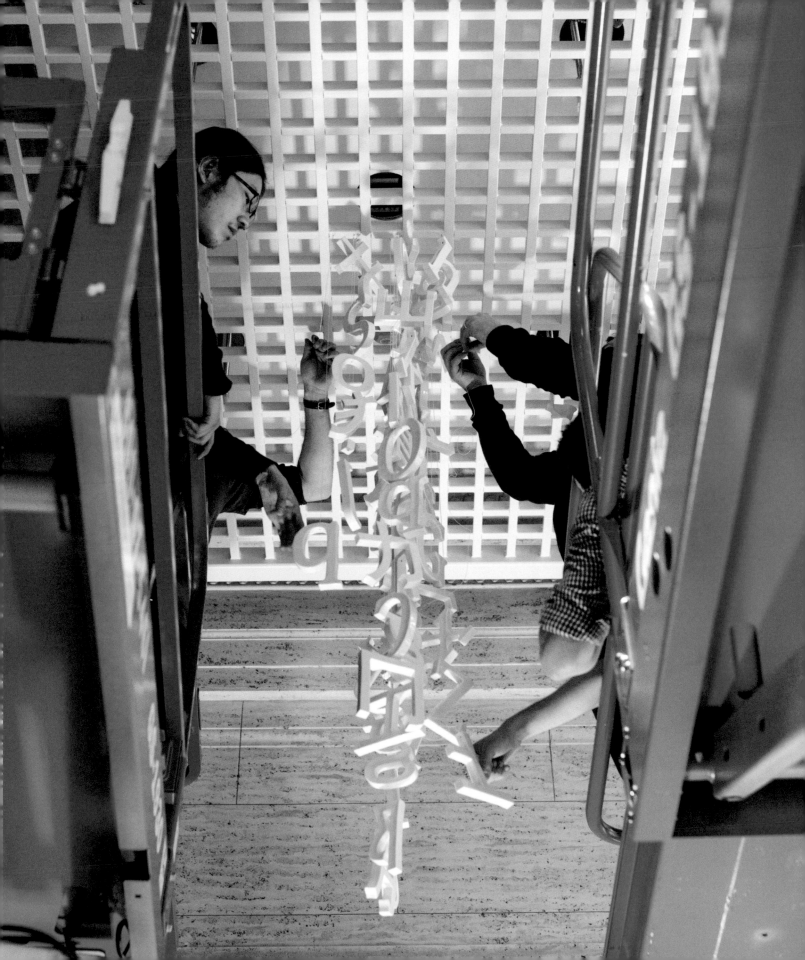

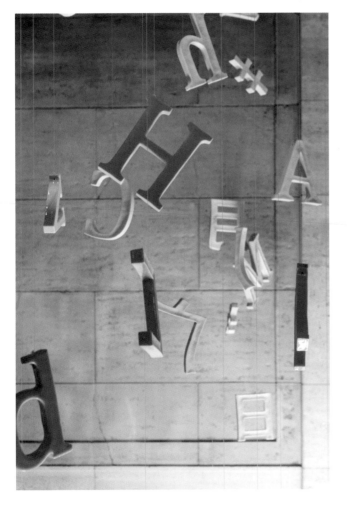
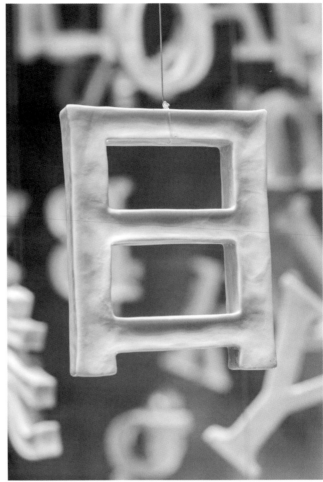

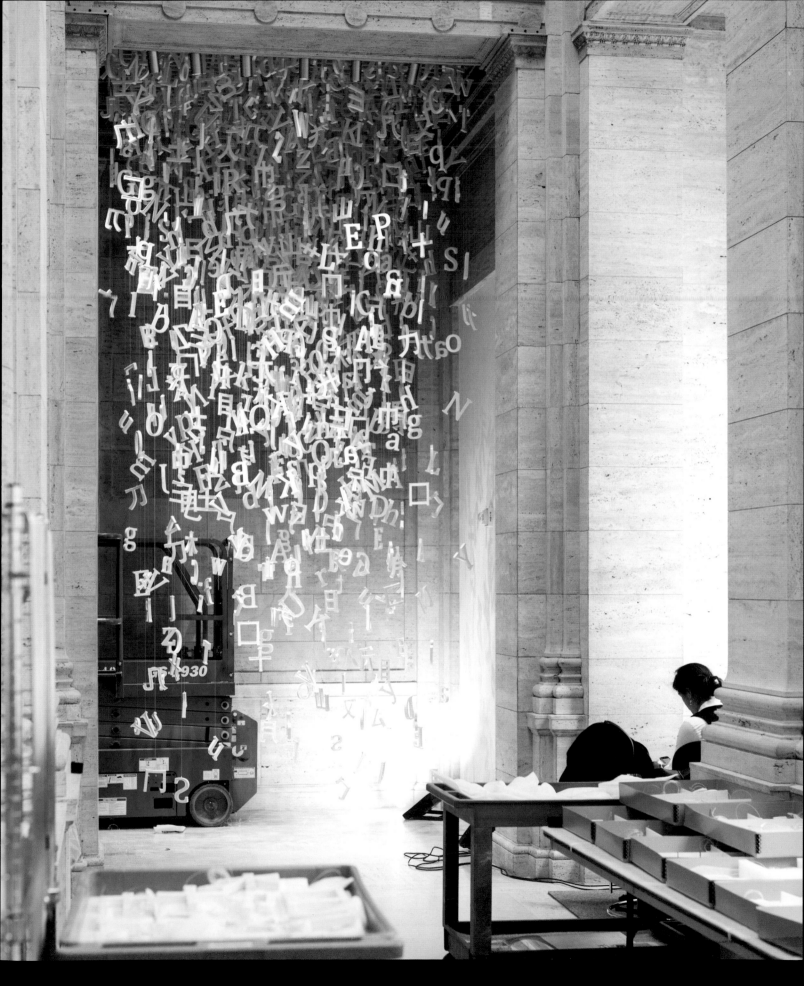

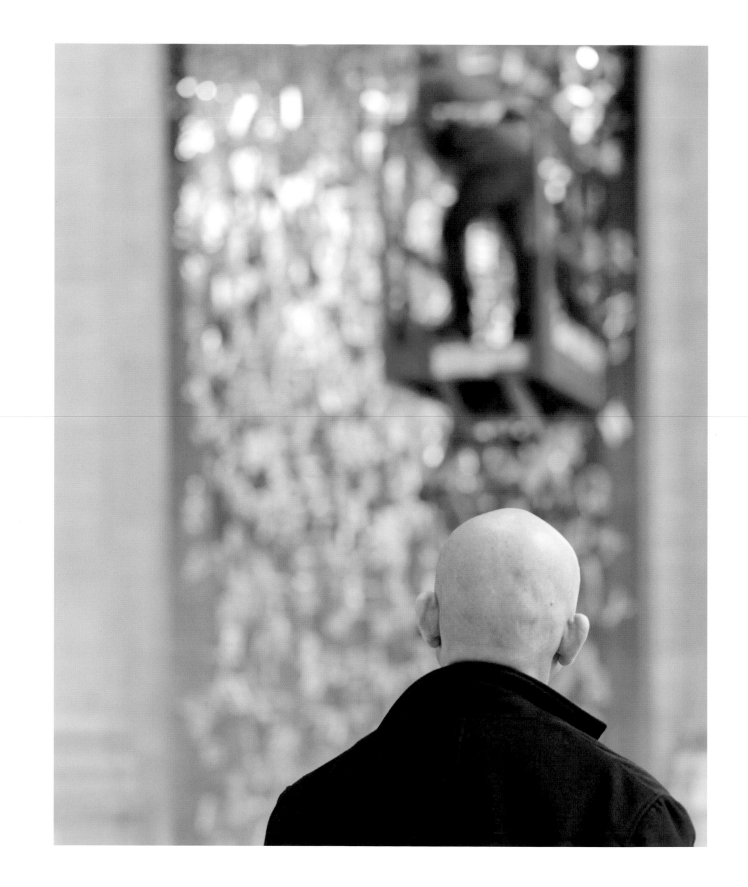

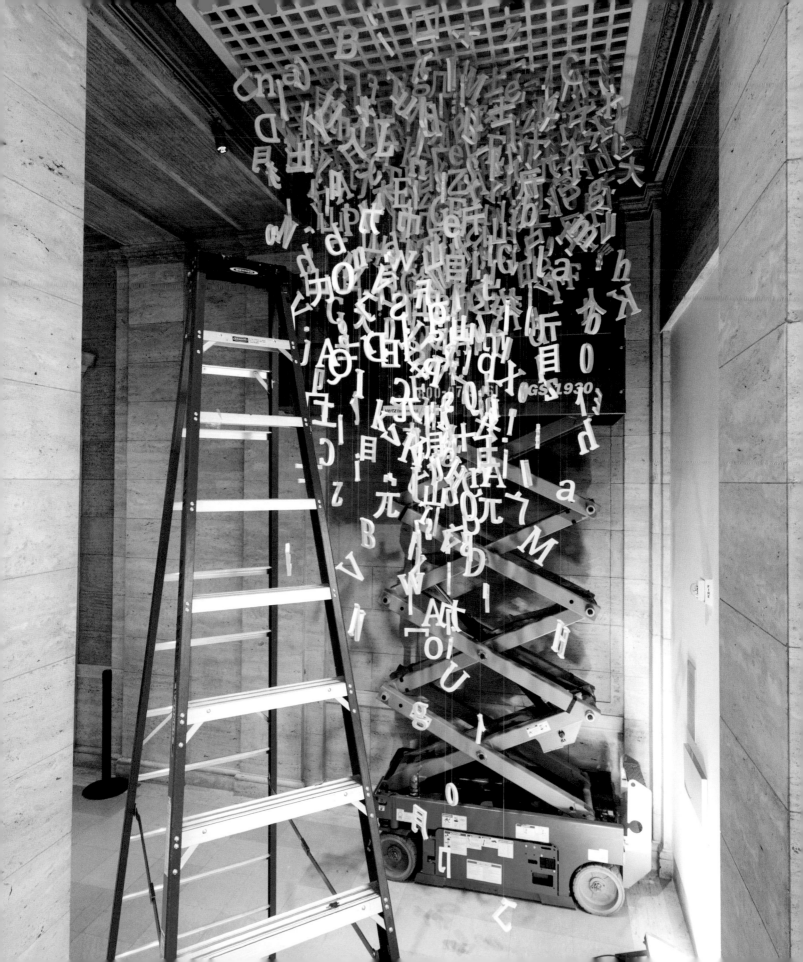

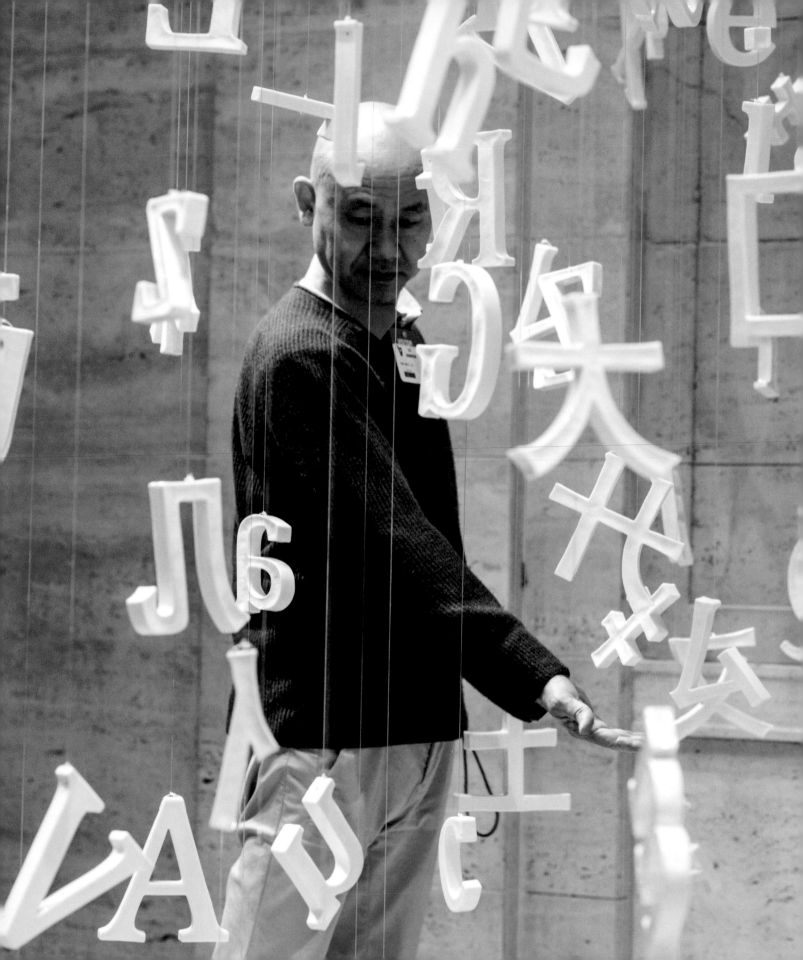

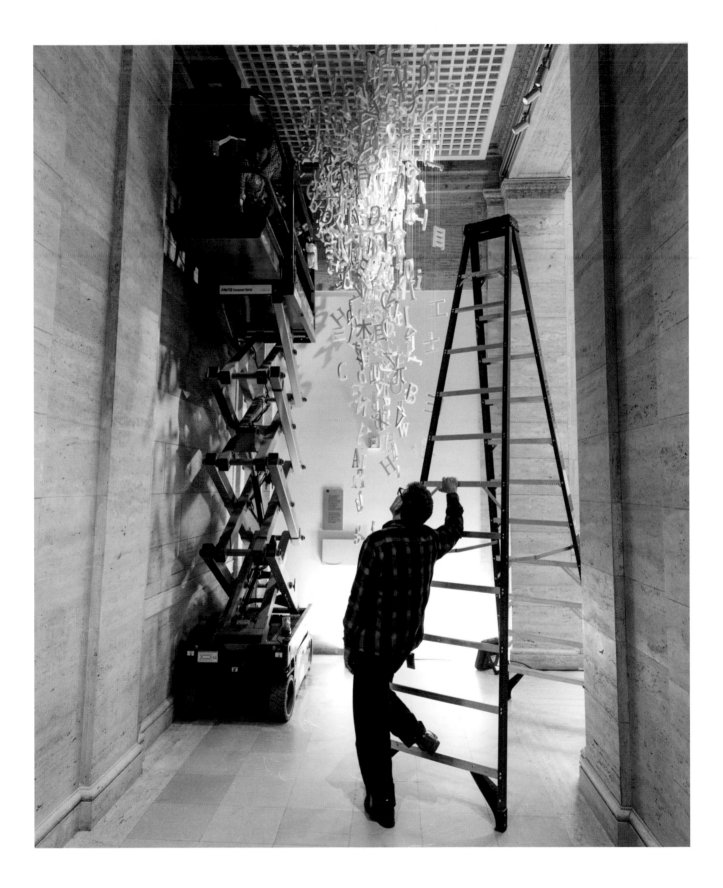

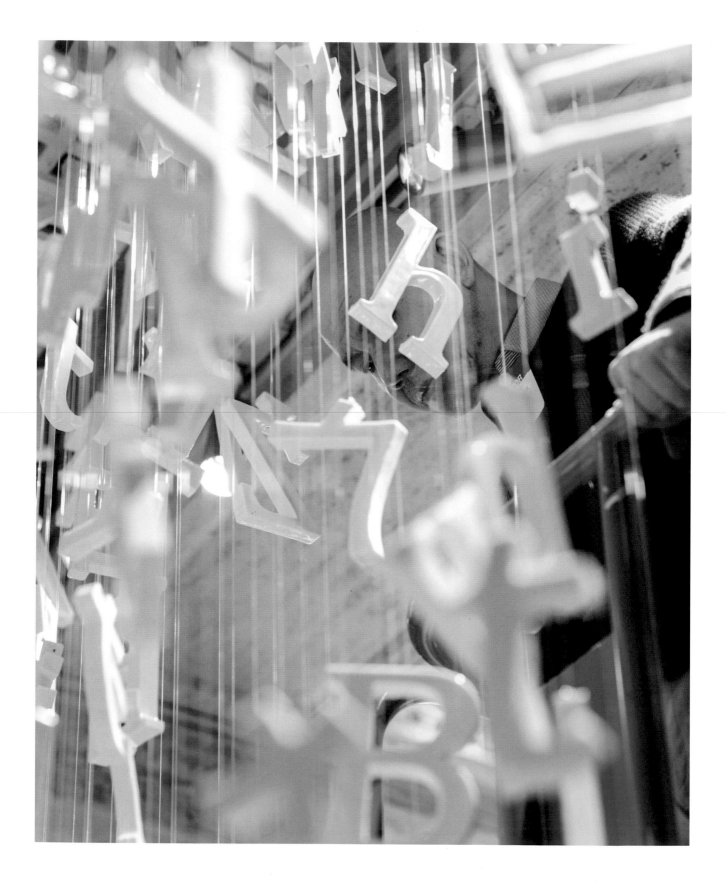

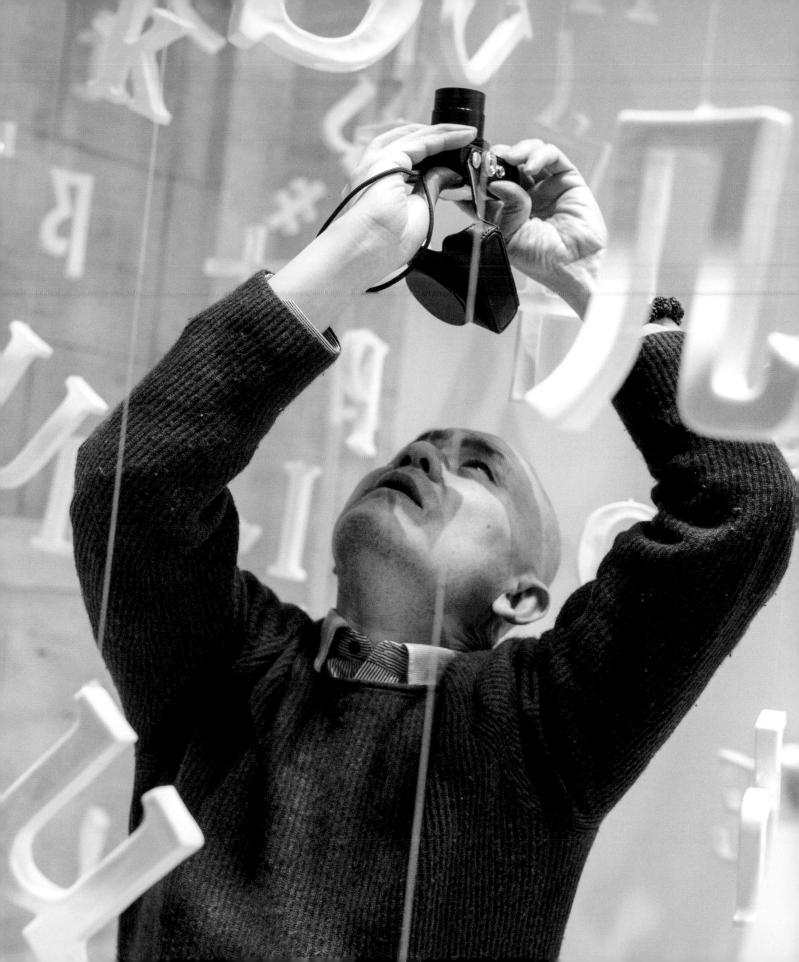

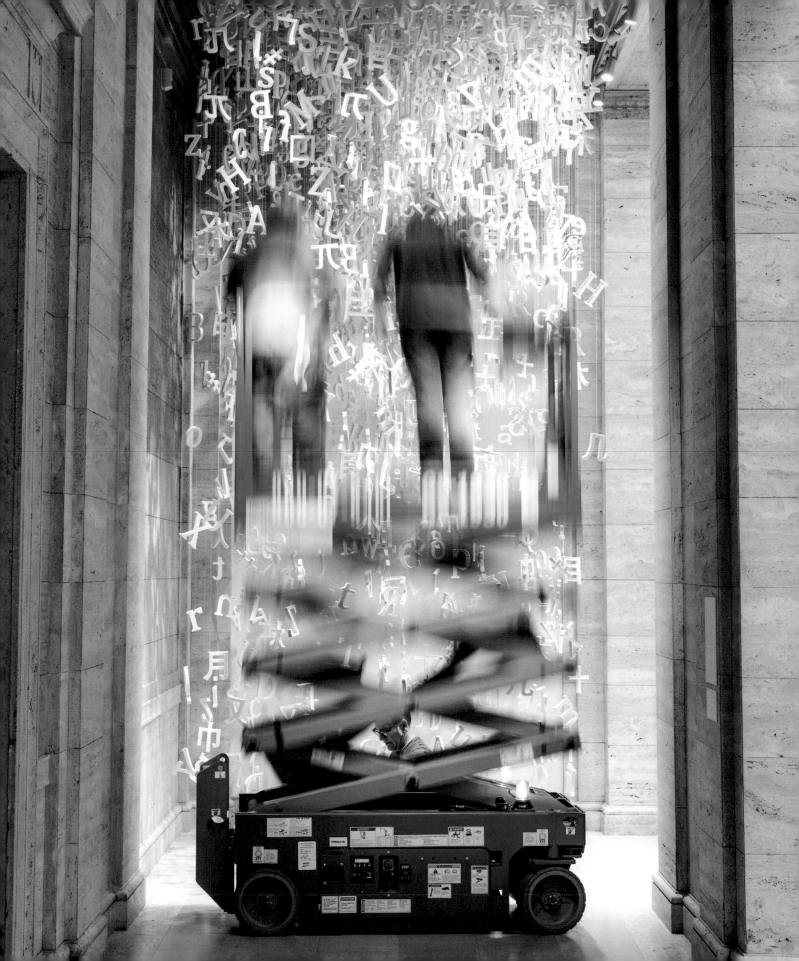

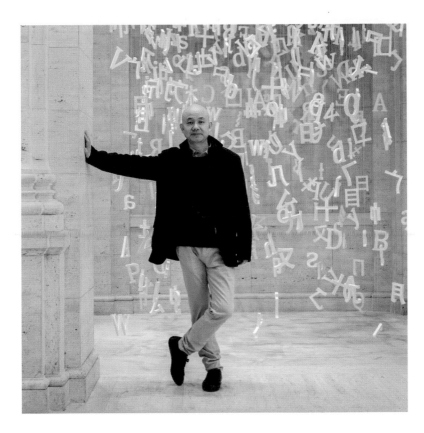

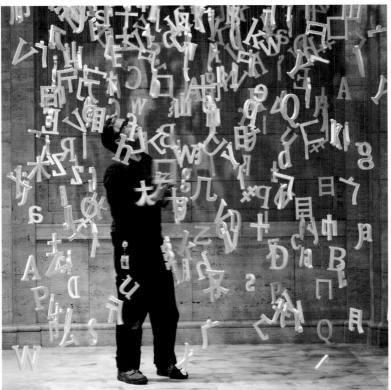

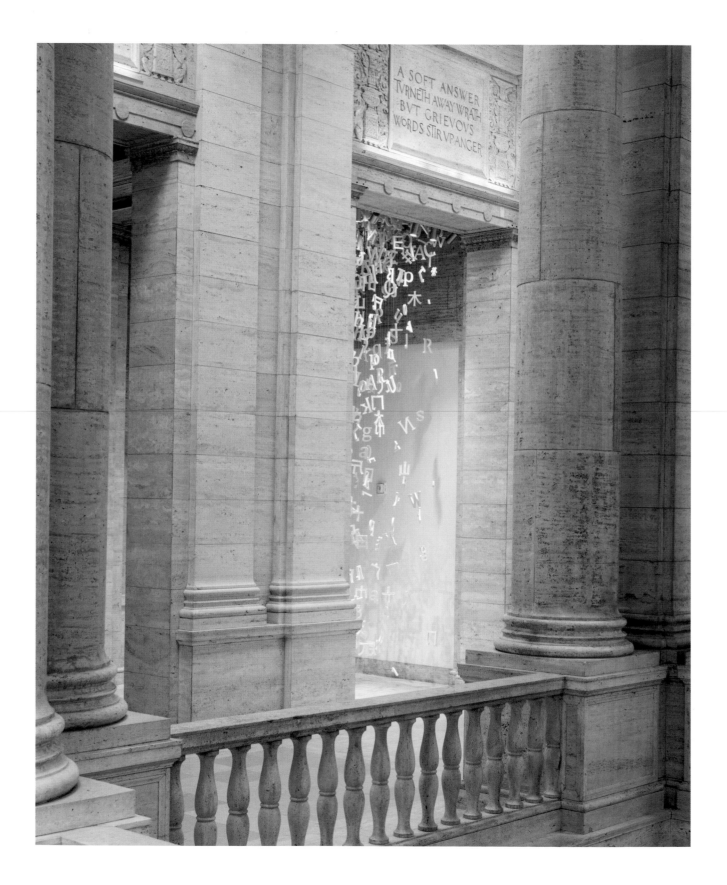

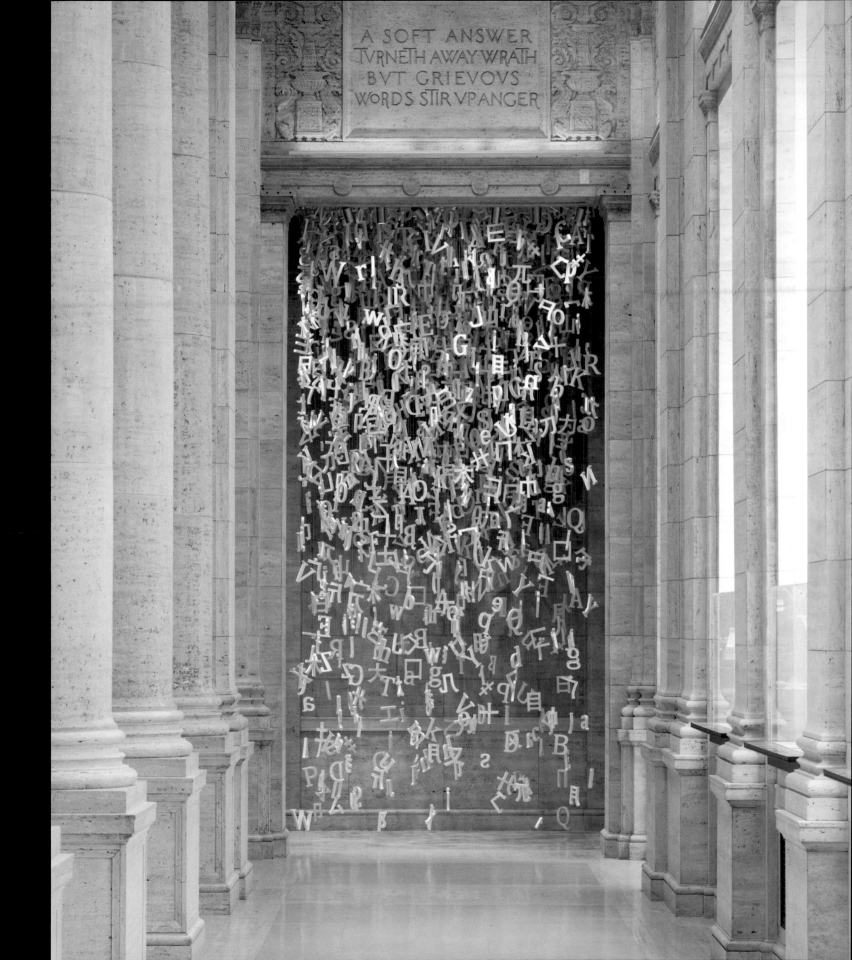

A SOFT ANSWER
TVRNETH AWAY WRATH
BVT GRIEVOVS
WORDS STIR VP ANGER

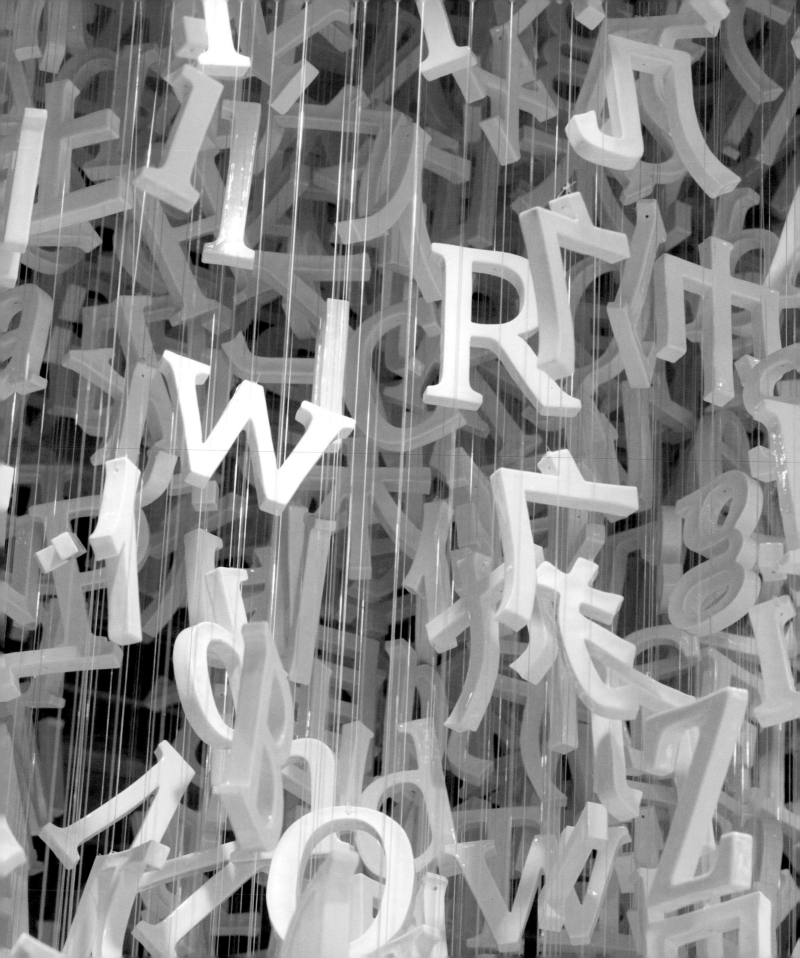

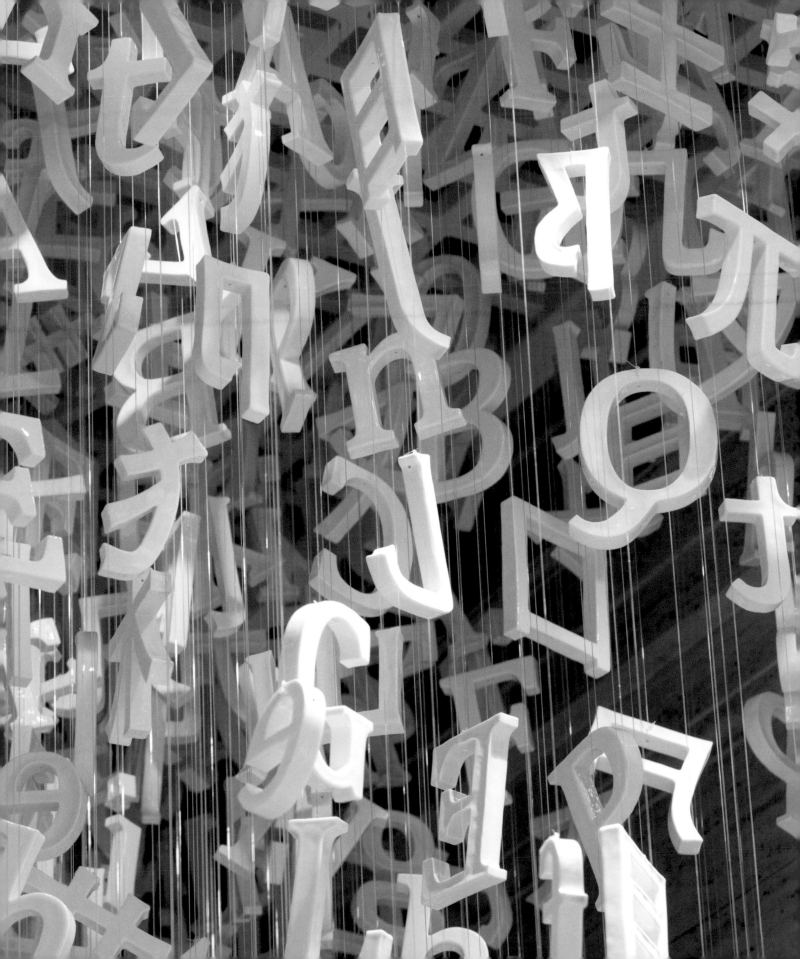

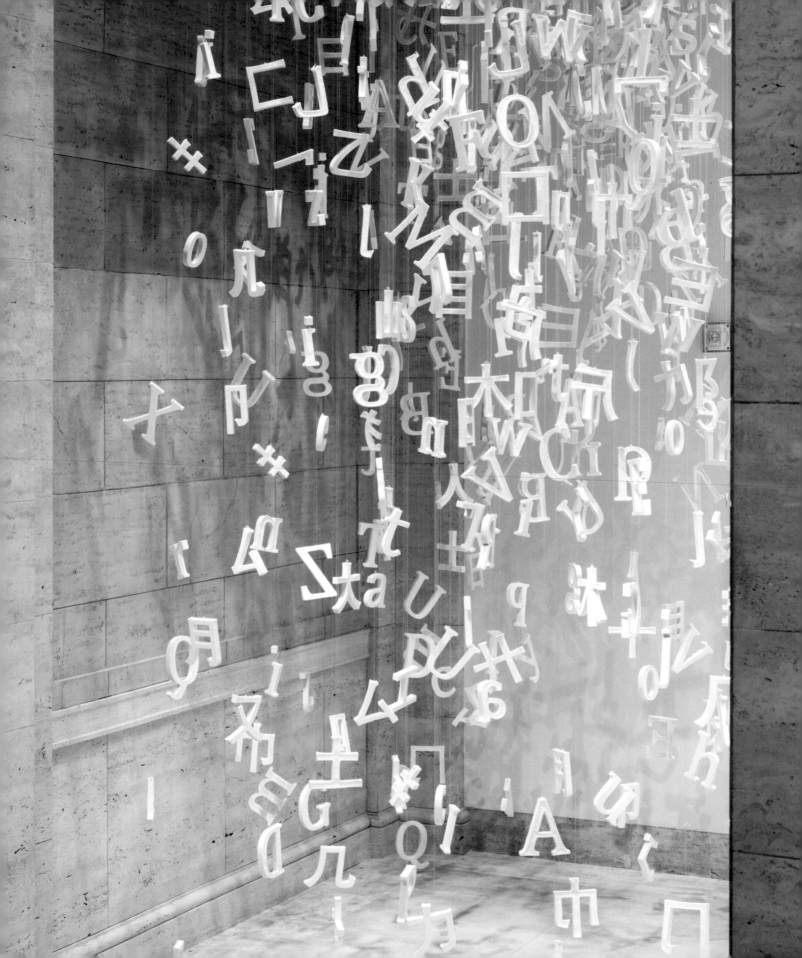

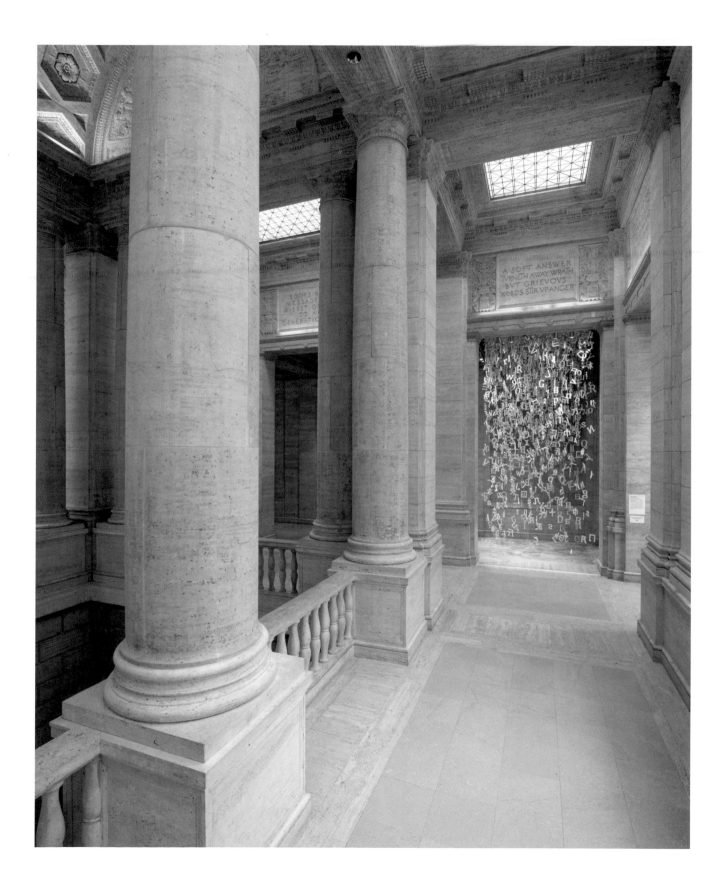

FROM LIBRARY TO MUSEUM: LIU JIANHUA'S LETTERS OF KNOWLEDGE

PEDRO MOURA CARVALHO

Almost one hundred years ago, San Franciscans had a further good reason to celebrate the reconstruction of their city after its devastating earthquake. For it was in 1917 that the city inaugurated the Main Public Library, a building that remains one of the city's finest. This was a place where, for over seven decades, both locals and outsiders congregated to learn and where knowledge was cultivated.

Then, in 1994, local voters decided that this grand structure, designed by George W. Kelham (1871–1936), would be transformed into a modern museum, the home of one of the great collections of Asian art. The building's visitors were no longer expected to spend hours reading; instead, they are expected to learn about the myriad cultures that form what is conventionally called "Asia" as well as large parts of Southeast Asia and the Islamic lands.

Other than the library's facade and sidewalls, only its grand staircase, former card catalogue room (now known as Samsung Hall), and Loggia were kept intact. In contrast to what is often seen across the United States, these three extraordinary spaces were not mere pastiches of fine Continental architecture. They follow the classical conventions of the beaux arts style and exhale the grandeur and elegance that characterizes the finest examples of such movement, overwhelming visitors with balanced proportions and formidable scale. The travertine stone confers an unusual lightness to the columns, the balustrade, and the carved ornamentation. This effect is emphasized by the abundant natural light brought by the transformation led by the Italian architect Gae Aulenti (1927–2012). Her renovation of the building concluded in 2003, the year that marked the opening of the Asian Art Museum in the San Francisco Civic Center.

From 2003 until today, the Loggia has been used to display part the museum's collection of Chinese porcelain, one of the its greatest assets. A selection of Song, Yuan, Ming, and Qing dynasty vessels reveals the knowledge and experience accumulated by Chinese potters over eight centuries. Courtly wares made in Song dynasty kilns such as Ding, Jun, Ge, and Guan, as well as Longquan celadons and Qingbai, Jian, and Cizhou pottery, are displayed alongside vessels made in later periods in what became known as the porcelain capital of the world, Jingdezhen.

Exceptional creativity, technical expertise, and quality of craftsmanship allied with—more often than not—a considerable aesthetic sensitivity allowed Chinese potters to innovate in a field that would seem to have limited prospects. During the twentieth and twenty-first centuries, surprising artworks and striking installations made in delicate porcelain continued to be produced in Jingdezhen. Contemporary artists and potters remain fascinated by the intrinsic qualities of porcelain, but until recently the display in the Asian Art Museum's Loggia did not reflect this interest. Happily, this has now been amended by the first installation commissioned by the museum to be on long-term view.

Liu Jianhua's installation shows the enormous potential of the porcelain medium. After living and working for many years in Jingdezhen, he learned to work porcelain in novel fashions. He models and glazes in ways that surpass the medium's limitations; he enjoys playing with illusions, likes to emulate nature, and is inspired by different environmental and social issues. His work at the Asian Art Museum pays tribute to the building's original use, and its combination of the Latin alphabet and Chinese radicals reveals his interest in the wise sayings carved in the Loggia as well as in cross-cultural themes that are crucial to the museum's work and San Franciscans' lives. It is particularly fortunate that the Society for Asian Art has sponsored Liu Jianhua's new work, thus celebrating the fiftieth anniversary of the museum in the most consequential and generous manner.

The alphabet and radicals of *Collected Letters* are symbolic of knowledge. The spread of knowledge remains as critical today as it was a century ago, making the work of the Society for Asian Art and the Asian Art Museum as relevant as ever.

CONTRIBUTORS

Jay Xu is Director, Asian Art Museum of San Francisco.

Linda Shen Lei is President, Society for Asian Art.

Liu Jianhua is a Shanghai-based artist.

Tiffany Wai-Ying Beres is an independent curator
and Chinese art historian.

Karin G. Oen is Assistant Curator of Contemporary Art,
Asian Art Museum of San Francisco.

Pedro Moura Carvalho is former Deputy Director, Arts &
Programs, Asian Art Museum of San Francisco.